Sargent at Broadway
The Impressionist Years

Sargent at Broadway
The Impressionist Years

Essays by Stanley Olson,
Warren Adelson, and Richard Ormond

Universe/Coe Kerr Gallery
New York

John Murray
London

Published in the United States of America
in 1986 by Universe Books
381 Park Avenue South, New York, N.Y. 10016

First published in Great Britain 1986
by John Murray (Publishers) Ltd
50 Albemarle Street London W1X 4BD

86 87 88 89 90 / 10 9 8 7 6 5 4 3 2 1

Printed in Hong Kong

British ISBN 0 7195 4319 3

Library of Congress
Cataloging-in-Publication Data

Adelson, Warren.
 Sargent at Broadway.
 1. Sargent, John Singer, 1856–1925—
Contributions in American impressionism.
I. Olson, Stanley. II. Ormond, Richard.
III. Title.
ND237.S3A84 1986 759.13 85-24595
ISBN 0-87663-492-7
ISBN 0-87663-889-2

Contents

Acknowledgments 7

Sargent at Broadway by Stanley Olson 11

John Singer Sargent and "The New Painting" by Warren Adelson 25

Carnation, Lily, Lily, Rose by Richard Ormond 63

Plates 77

Acknowledgments

When we commenced our work on the Sargent *catalogue raisonné* in 1980, the chronology of certain periods of the artist's work was undefined. Information about his early years in Paris was disorganized, his travels to Italy, Spain, and North Africa were poorly documented, and the dates of his trips to Venice were unclear. But nothing was more challenging for us than his early years in England. Broadway, Calcot, and Fladbury struck fear in our hearts. Was such and such painted in one place or the other, in 1888 or 1889? Was that picture painted at Broadway or at Nice, or was it done after 1900 in some other place altogether? Clearly, this morass had to be sorted out. What better way to do it than to assemble a representative selection of the works, as suggested by our colleague, Richard Ormond. This exhibition and publication are the results of that undertaking.

In three essays, we have attempted to explain the chronology of Sargent's venture into Impressionism and to describe the influences that were critical in guiding his path. We trace his student beginnings in the atelier of Carolus-Duran and his contact with the vast pool of influences in Paris of the 1870s, with particular emphasis on his connections with Manet, Degas, Renoir, and, most notably, Monet. Sargent's relationship with Monet has been the most frequently cited and least explored aspect of these critical years. We have tried to describe and explain the long and rich relationship between these two great painters and to make clear the older artist's influence on the younger. We have also examined other influences, especially that of contemporary nineteenth-century British painting.

Many people have assisted us in the realization of this project. We were extremely fortunate to have the cooperation of several residents of Broadway, especially Dr. C. C. Houghton, the village historian, Dr. Margaret Moore, and Lord Birdwood. With their assistance we were able to visit the houses and gardens Sargent painted and in this way identify the sites shown in several paintings. Mrs. Joyce Sharpey-Schafer, granddaughter of Frank Millet and author of *Soldier of Fortune: F. D. Millet*, has been immensely helpful to us from the outset of the project, making available to us her broad knowledge of the period, the sites, and the "guests" her grandmother, Lily Millet, received at Broadway in the 1880s. We are also grateful to the Mehans of Calcot and to Mrs. P. B. Monkman of Fladbury for their gracious hospitality. During visits to all of these sites, Jan P. Adelson took many stunning photographs of the rivers, gardens, and houses that Sargent painted. A selection of the photographs is reproduced in this book.

The classic work on French Impressionism is John Rewald's *The History of Impressionism*, and this seminal book served as a beacon of light in attempting to describe the context for Sargent's art of the 1870s and 1880s. William H. Gerdts's comprehensive volume, *American Impressionism*, served as a backdrop for the American point of view. The early biography of Sargent by Evan Charteris (1927) was a basic reference work for our research, as were the biographies by William Howe Downes (1925) and Charles Merrill Mount (1955). Richard Ormond's monograph on Sargent (1970) contains many of the ideas that we have developed in this book; that work was of inestimable value for this one. The more recent scholarship of Trevor Fairbrother and Carter Ratcliff was also of great value. Stanley Olson, author of the latest Sargent biography (1986), allowed us to read the manuscript before publication, and we benefited by knowing the new material he has uncovered.

Several people lent us their expertise once the manuscript was written. Frances Weitzenhoffer advised us "from the French side" and made many excellent suggestions regarding content and style. Arthur Prager edited the manuscript with consummate skill. Carol Flechner did a superb job as copy editor and production coordinator for the book. Our special thanks to Patricia Wynne for drawing the beautiful map detailing Sargent's stops in the English countryside during the 1880s.

In undertakings of this kind, everyone at Coe Kerr helps in countless ways. We are especially grateful to Odile Duff, who works on the Sargent *catalogue raisonné*, for her tireless and inspirational efforts in developing the material; to Constance Gallant, who did an excellent job as registrar for the exhibition; to Leigh Morse for her skillful management of the publicity for the exhibition; to Mary Ramniceanu, who had the daunting task of typing the manuscript; and to Donna Seldin, who coordinated the entire project.

Finally, our greatest debt of thanks is due to the private and public lenders who made the exhibition possible. Many of these paintings are requested constantly for loans, and we were very fortunate in being able to borrow almost every painting we had selected. The Ormond family was remarkably generous is lending many fine and little-known works. Mrs. John William Griffith lent us a garden scene from 1886 that demonstrates uniquely Sargent's attempts at painting light and shadow. Mr. and Mrs. Raymond J. Horowitz lent us their beautiful watercolor painted at Calcot in 1888, the only watercolor in our show dating from that year. And other private owners who wish to remain anonymous each made significant contributions to the exhibition.

We are very grateful to the museums that parted with their pictures for this occasion. Our thanks to Linda S. Ferber, chief curator and curator of American painting and sculpture, The Brooklyn Museum; Samuel Sachs II, director, and Nancy Rivard Shaw, curator of American art, The Detroit Institute of Arts; Michael Jaffé, director, and David Scrase, keeper of paintings, drawings and prints, Fitzwilliam Museum, Cambridge; Richard J. Wattenmaker, director, Flint Institute of Arts; John K. Howatt, Lawrence Fleischman Chairman of the Departments of American Art, The Metropolitan Museum of Art, New York; Robert J. Koenig, director, Montclair Art Museum; Clifford Ackley, curator of prints, drawings and photography, Barbara Stern Shapiro, associate curator of prints, drawings and photography, Theodore E. Stebbins, Jr., John Moors Cabot Curator of American Painting, and Trevor J. Fairbrother, assistant curator of American paintings, Museum of Fine Arts, Boston; John H. Dobkin, director, National Academy of Design; Dr. John Hayes, director, National Portrait Gallery, London; Linda Muehlig, assistant curator of painting, Smith College Museum of Art; Ambassador Daniel J.

Terra and Michael Sanden, director, Terra Museum of American Art; Paul A. Chew, director, Westmoreland County Museum of Art; and Helen Cooper, curator of American paintings and sculpture, Paula Freedman, assistant curator of American paintings and sculpture, and Michael Komanecky, assistant to the director, Yale University Art Gallery.

The opening of *Sargent at Broadway: The Impressionist Years* at Coe Kerr Gallery was a benefit for the Royal Oak Foundation, Inc., an American charity that serves as the American affiliate of the National Trust of Great Britain. The proceeds from the opening will be used for the restoration and maintenance of Igtham Mote, a medieval manor house in Kent that Sargent visited and painted in 1889. We are delighted to contribute to this cause, and we extend our thanks to Arthur Prager, executive director of the Royal Oak Foundation, and Lisa Oldenburg, membership secretary of the Royal Oak Foundation, for their enthusiastic participation in this project.

Warren Adelson
Director, Coe Kerr Gallery

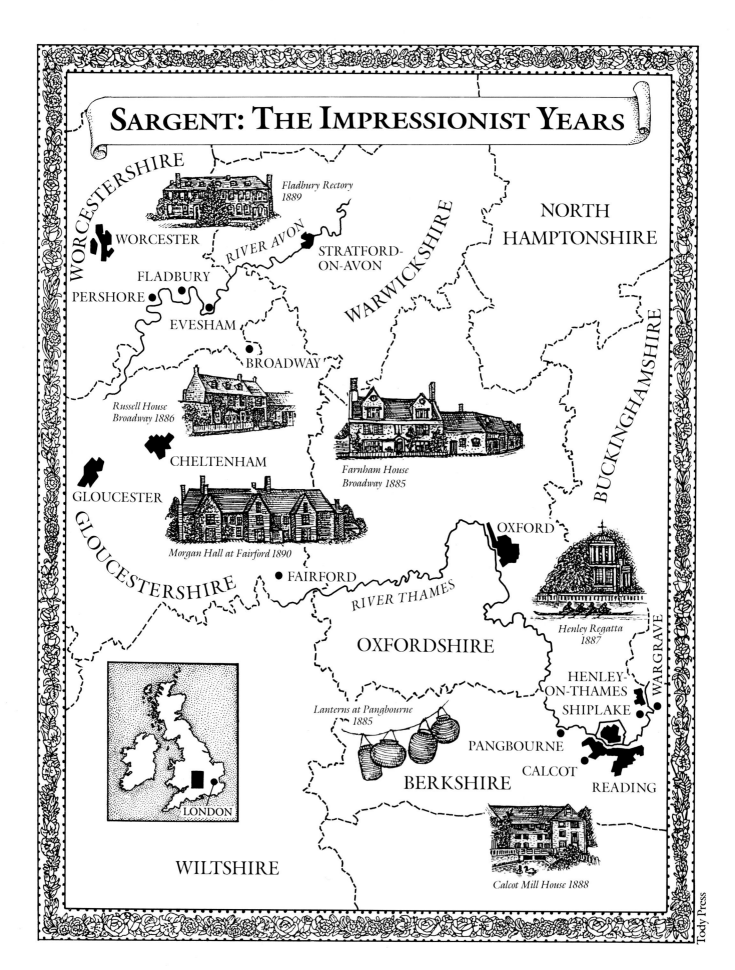

SARGENT: THE IMPRESSIONIST YEARS

WORCESTERSHIRE

Fladbury Rectory 1889

WORCESTER

RIVER AVON

STRATFORD-ON-AVON

WARWICKSHIRE

NORTH HAMPTONSHIRE

FLADBURY

PERSHORE

EVESHAM

BROADWAY

Russell House Broadway 1886

CHELTENHAM

Farnham House Broadway 1885

GLOUCESTER

BUCKINGHAMSHIRE

Morgan Hall at Fairford 1890

OXFORD

GLOUCESTERSHIRE

FAIRFORD

RIVER THAMES

Henley Regatta 1887

OXFORDSHIRE

WARGRAVE

HENLEY-ON-THAMES

SHIPLAKE

Lanterns at Pangbourne 1885

PANGBOURNE

CALCOT

READING

BERKSHIRE

LONDON

Calcot Mill House 1888

WILTSHIRE

Tody Press

Sargent at Broadway

by Stanley Olson

Sargent's introduction to Broadway was the happiest accident in his life. Of course, the timing was fortuitous, coming just as he faced the disturbing truth that the slow, uneasy denouement of his years in Paris had been set in motion. His otherwise sober detachment, equanimity, and confidence were in a peculiar state of disarray, his loyalties disturbed—all of which made him excessively vulnerable to the holiday atmosphere he found in Worcestershire. He extended his stay from weeks to months, returned the following year, and thereafter continuously sought to duplicate the mood. For Sargent, Broadway was an unexpected holiday-turned-pastoral-idyll, pastoral-idyll-turned-symbol. In large terms, it represented the only entr'acte in his history: from 1885 until 1890 the forces of transition gathered strength to remodel him for the adjustment to his mature career.

But this reading is from the reverse angle of perspective. At the time, he appeared an unlikely victim for any radical shift of temperament or action; the drama thus far seemed to be unfolding according to some majestic, well-directed plan. Sargent was twenty-nine years old. In a comparatively short span of time, he had found a respectably high perch for himself, especially for one so young and a foreigner (as the French hastily distinguished), and to the casual observer he was poised for even greater achievement. Since the late 1870s, the graph of his success at the Salon rose each year. In truth, however, these annual showings had soured into repetitive trials. Despite the notice he had accumulated, he was unable to emerge into the bright light of independence. He could neither free himself from his teacher's shadow nor escape the heavy burden of promise. By 1885, he sensed that he had not mastered the challenge he had willingly accepted. He felt unequal to it, and he had had enough. This deep frustration was, however, the culmination of many petty injustices constantly in attendance during the passage from student to professional, and Sargent had never addressed himself to them for a host of reasons, beginning with his natural lack of introspection and ending with his blind loyalty to the rigid tradition he had accepted from the beginning. When he enrolled in the atelier of Carolus-Duran in the spring of 1874, he put his name to a contract that tied him to the ruling values of the reigning art universe. And his eagerness for any education, so many years postponed, sealed the agreement.

The first dramatic element was thus dropped into the text, for while the hierarchy of his studentship did advance beyond the atelier to the Academy, the École des Beaux-Arts, and then the Salon, he always returned to the fixed point of his teacher. It was an inescapable partnership; even the Salon catalogue carefully defined exhibitors by their ateliers. For Sargent, this perpetual cou-

pling eventually became a suffocating obstacle. Once Carolus had ceased to be his teacher, the towering presence remained, transforming their relationship into one of muted competition. And of all the patrons at the time, Carolus did cast the most dauntingly long shadow, manufactured never to be ignored. Carolus adored fame, reveled in every atom of it, with a cool forgetfulness of how he had achieved it.

The story of Carolus-Duran (1838–1917) was one of the triumph of brute determination: the unfortunate provincial who, after years of diligent application, overcame poverty, the lack of academic training, and ill fortune to take Paris by storm, having ridden on the high wave of rebellion, breaking rule after rule, laughing off the jibes of the older generation as he became the darling of the younger generation. Looking at his paintings today, it is hard to credit (or understand) such a meteoric flight. But at the time, when he opened his palette to brilliantly vivid hues and poached Manet's approach to portraiture, the public was taken by surprise—the Salon public, that is. Carolus was at the very apogee of his fame when Sargent first came under his spell, shortly after the teaching studio opened on Boulevard du Montparnasse. And it was then that the fatal flaw in Carolus's personality showed itself. Though he only had his fame to recommend him as a teacher and none of the more useful qualities of knowing or appreciating the value of academic training, he acquiesced when petitioned to teach, heedless of his profound ignorance, an ignorance that would render his students wonderfully underqualified for the grueling entrance examinations for the École. To him, instruction was one of the penalties of fame, and from the moment he became a teacher, his career executed a neat *volte-face* which eventually turned him into a near-parody of conventionality, highly groomed with overweaning snobbishness, an insatiable affection for money, titles, and official honors (and by the end of his life, he had gathered in an enormous number). Yet, before the slide into utter complacency was complete, he was a hypnotic figure to his students with his bold independence, his swashbuckling manner, his outlandish mode of dress, his vitriolic temper, and his mesmerizing aura of worldly success. His lessons turned into acts of devotion; every syllable he intoned carried the weight of edict. While his own paintings might have been refreshingly radical, his ambition carried him straight into the hallowed precincts of the Academy, and in the end his students drifted out to their careers no differently than those students who had moved out from the solidly established moorings of the ateliers of Cabanel, Gérôme, Pils, Bonnat, and Yvon—the very lions who had once growled at the spectacle of Carolus. Carolus's real, though unspoken, lesson was nothing more than a wholehearted endorsement of traditional views. And Sargent absorbed it totally.

When Sargent turned away from Boulevard du Montparnasse to make his advance on the Salon, his campaign was a modified, updated, but equally calculated version of Carolus's own decades before—deliberate, and deliberate to a pattern from the start in 1877. He was mindful to adjust his submissions to both etiquette and popular taste. The first year a portrait, the next a subject picture, then back to a portrait, and by 1880 he sent one of each. Sargent's Salon advertisements carried a large message, informing the public that he, of course, was available for portrait commissions. Yet he was equally determined to avoid any exclusivity, for his subject pictures—*The Oyster Gatherers of Cancale* (1878) (Fig. 8) and *Fumée d'ambre gris* (1880)—gave notice that he wanted to excite attention by appealing to fashion because narrative scenes were more noteworthy than portraits. This was the usual tempo of the Salon march, and Sargent was keeping step.

In 1879, he boldly submitted a portrait of Carolus, a picture that signaled both the end of his apprenticeship and the start of his bid for independence. In truth, however, he was merely slipping out of one influence and into another. No sooner had he left Boulevard du Montparnasse than he enrolled in another atelier, going straight to Spain for a vigorous firsthand Velázquez tutorial, and then another, in Holland, for Hals's. And after his Velázquez and Hals tutorials, his measured stride in the Salon began to lose its edge. He sent nothing in 1881. But in 1882 he quickened his pace, sending a portrait of Miss Louise Burckhardt (*Lady with the Rose*) and a startling dance scene (*El Jaleo*), and seemed to recapture lost ground. But appearances obscured failed motives: for the past two years he had vainly sought a Venetian subject for the Salon, not a Spanish one, and only revived out-of-date notes in *El Jaleo*. Still, he had engineered a steady incline on the graph of his reputation. The next year (*The Daughters of Edward Darley Boit*) he further tightened the grasp on his command, and by 1884 the public was poised for another striking installment. But when his daring portrait of Madame Pierre Gautreau was unveiled, he had managed to evoke the wrong sort of excitement—an excitement soured by notoriety. For Sargent such a reaction was doubly grave. His grand strategy had collapsed. According to pattern, there should also have been a subject picture; and for the second time he was defeated (and this time he had no reserves). But, more importantly, Sargent had never known adversity or failure. For the previous ten years his development had been majestically, almost impossibly, assured, wholly unclouded by uncertainty, moving swiftly along a straight line from being Carolus's star pupil to being one of the most promising painters of his generation. The sad curiosity of *Madame Gautreau* was a disastrous interruption simply because of his total ignorance of failure. It sent a slow-working poison through his veins that gained toxicity over the next few years. But despite this apparent reversal, he was unwilling to withdraw or to relinquish his faith in his strategy. He continued to believe that the Salon held the key to his future, and fortunately he had commissions to satisfy in England.

The three months he expected to be kept in England stretched to six, but by the beginning of 1885 he was back in his Paris studio, where he bravely stayed for seven months. In July 1885, he recrossed the Channel for his summer holiday, and, as it turned out, the Paris dialogue was silenced. The curtain was slowly brought down on the first act.

The unhasty transition from Paris to London was a marvelously, delicately worked scene, subtly crafted in partnership. While Sargent waited, addicted to optimism—and conditioned by his family's belief in postponement—another stage manager strode forward, busying himself marshaling in new characters, conjuring new motives for the next episode in Sargent's history: Henry James. James wasted a lot of ink in his bid to turn his fiction into reality, and yet he had a willing and compliant subject in Sargent. James replaced Carolus, and the writer's influence told strongly at a vital moment and lingered on for decades.

James had been reworking Sargent's character in letters and conversation since they had first met in Paris in February 1884. The writer's original sketch was laced with distant admiration—"high talent, a charming nature, artistic and personal, and is civilized to his finger-tips"—and at that time Sargent was ineligible for James's assistance. Still, James could not resist the urge to meddle just a little, and he got his chance when Sargent made a fleeting visit to London at the end of March. Before Sargent arrived, James confessed he wanted to give the artist "a push to the best of my ability;" by the time Sargent left, it was clear that James had underestimated his own strength. In just a few days, James's address book and diary had called up a new and mighty supporting cast—the

Pre-Raphaelites, the stage (in the shape of actor Lawrence Barrett), and both art and the theater in the shape of other expatriate American artists. The lure of London was held out in the most delectable manner, taking the first step in James's preposterous alchemy. But even James was unable to establish Sargent in England on a comparable level to that in Paris; in London, Sargent really was as good as unknown. A month later, after the sad showing of *Madame Gautreau* at the Salon, both places suddenly seemed equal. James seized this unexpected boost in his experiment, amplified his appeals to near deafening volume, declared undying service, and forecast victory. Paris was cast as the villainess of the piece, and London was wheeled into the position of savior. Sargent came back to London at the beginning of June as he had promised months before, and James's wizardry gained strength (if possible): the tantalizing taste of London served up on the first visit swelled to a main course on the second. James was sensing the intoxication of triumph.

The hand of Henry James was discernible behind the sequence of events that took nearly two years to reach maturity and that finally ended Sargent's attachment to Paris, produced his least characteristic works (and one of his chief successes), sent him deeper into the countryside, retrieved him from disgrace as a portraitist, summoned his parents and sisters from Nice, and deposed Carolus, Velázquez, and Hals in order to make room for Monet. These large consequences came about simply enough. Sargent left London, went on a boating expedition from Oxford to Windsor (made shorter by an accident), and visited Broadway, where he entered the laboratory of plein-air

Broadway Green, c. 1895. Photo courtesy of Dr. C. C. Houghton, Broadway

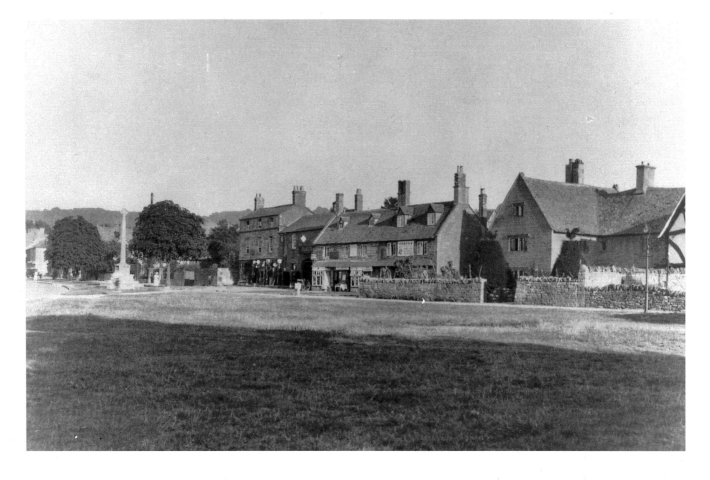

painting. And it all began when Sargent returned to England for the third time in seventeen months, in the summer of 1885. His companion throughout was Edwin Austin Abbey (1852–1911)—"Ned." When James produced Abbey during Sargent's second visit, James had executed his best sleight of hand yet.

Abbey was a delightful character, high-spirited, tailored for companionship, alive in a crowd, energetic, with a finely modeled sense of humor. He was also a very brilliant draftsman and, later, painter. While other Americans of his generation succumbed to the siren call of Paris to improve their art training, Abbey heard nothing and stayed at home. But in 1876, when he went to the Centennial Exhibition in his native Philadelphia, he suddenly heard alluring music, loud and enticing, as he approached the canvases of Millais, Watts, and Leighton. Two years later he sailed for England, where he stayed, industriously illustrating the works of Herrick, Shakespeare, Goldsmith, and Sheridan. He had a librarian's appetite for accuracy, which took him into the realm of costumes, for he would no more dream of drawing a cuff without researching and seeing it than he would illustrate a book without reading it (many times). And his interest in costumes took him into the theater. In short, he and Sargent approached their work through different doors, but it never hindered the course of their friendship. Sargent's affection for Abbey was absolute—"He is a delightful original genius," he wrote some years later—and when Abbey married, Sargent discovered such warmth of feeling did not travel—". . . and his wife has many virtues," he managed to tack on somewhat unfeelingly.

Sargent and Abbey set off on the boating tour in August (1885). The weather was perfect. About halfway, at Pangbourne, Sargent impetuously dived into the river. It was a mistake. He struck his head on a spike—"a nasty rap," Abbey reported—and almost the moment the wound was dressed, Sargent knocked his head again and reopened the gash. Abbey, predicting that playing nurse to this sort of patient would be unrewarding and unsuccessful, recommended they remove themselves from harm's reach, well distant from the river, to Broadway.

Indeed, Broadway, nestled in the vale of Evesham in the heart of the Cotswolds, owed much to geography. Throughout its long history, the tiny village sprang to importance briefly, and only because it lay in a good place to change coach horses on the run between Worcester and London. By the middle of the nineteenth century, when the railway passed through Evesham nearby, even that minor distinction was removed, and Broadway quietly slipped back into oblivion, graciously ignored by time, unchanged (almost). Today it is synonymous with a postcard picture of a dreamy English village, bringing a slight blush to the cheeks of natives and a swell of emotion in foreigners, which was the same spell it cast on the American painters who went there a century ago. Thereafter, the peace of anonymity was lost, especially once James discourteously repaid his hosts by pumping up their homes as tourist attractions in the pages of *Harper's Magazine* with phrases like "The place has so much character it rubs off."

For accuracy's sake, the real honor of starting the transformation of Broadway into one huge pictorial prop goes to the New Yorker Laurence Hutton (1843–1904), who never painted himself but was a collector, writer, and literary editor of what was to become the official Broadway paper—*Harper's Magazine.* The *Dictionary of American Biography* was well strained when trying to find some excuse to preserve him for posterity: "He had no creative gift . . . left no incisive criticism. . . . His writings are all gossipy, circumstantial, and superficial." Yet Hutton did have an expansive nature and was neither bashful nor restrained about revealing anything of the slightest importance; and after

John Singer Sargent, *Edwin Austin Abbey,* c. 1888. Courtesy, Yale University Art Gallery,

Fig. 1
Frank Millet. Courtesy private collection.

he had "discovered" Broadway on his travels, he rushed to dangle the beauty of the place in front of his friends in New York, the Millets. And so the gentle imperialism began. Francis Davis Millet (1846–1912) (Fig. 1) was the best sort of New Englander, torn between the pleasures of the mind and rollicking action, between his own work and public service. And as a result, he had a stunning career: war correspondent, author, translator, illustrator, muralist, painter, and indefatigable committeeman. If he had any flaw, it was his excess of abilities. His extraordinary achievements tended to obscure the nature of his character, already hidden by reticence, and his propensity, like Abbey, to move around in a crowd. His brain was uncomplicated though enterprising, and his temperament was unboisterous. He, too, was a marvelous draftsman, with a delicate touch and an overriding need for accuracy, sticking close to his source. In Paris in 1879, he married Elizabeth Merrill, the sister of a Harvard friend. The ceremony was witnessed by Mark Twain and Augustus Saint-Gaudens. Lily Millet (1855–1933) (Fig. 2) was strong-minded, engaging, intelligent, and strikingly pretty. Soon after her marriage, she grew increasingly uncomfortable shut up in the Millet family household in East Bridgewater while her husband went abroad, and she started to accompany him. By the middle of the 1880s they came abroad to stay.

The Millets had listened to Hutton's tales of Broadway and were instantly seduced when they saw it for themselves. But what had been for Hutton a curiosity became the Millets' home. They took Farnham House on the edge of the green, facing the old coaching inn. It was not a particularly large house, nor was it unusually beautiful; but it had the warm appeal of age—and it was in England. The vast tangle of people, friendships, activities, and associations reduced to the historic simplicity known as Broadway began at Farnham House. Millet, James wrote, "appropriated" Broadway, and soon the infestation began. Where Millet went, Abbey was sure to follow; they had been close friends for many years—one of the reasons the Millets had selected London for their honeymoon was Abbey's presence, and they named their first son after Abbey. And history has repaid their inseparable companionship by forever coupling their names (and the confusion *is* understandable).

Abbey and Millet, with their unrelenting bonhomie, were natural magnets, especially since illustrators seemed to be a breed constitutionally and professionally incapable of solitude. They needed a lot of people around them; their need for period costumes set a lot of fingers to work. Models came and went. Soon Frederick Barnard (1846–1896), famous for his illustrations of Dickens, was on hand with his wife and children, hotly followed by Alfred Parsons (1847–1820), Abbey's collaborator on the Herrick illustrations and an exceptionally keen and gifted gardener. Parsons had grown so accustomed to sharing his London house with the Millets and his studio with Abbey that it seemed only right he should rush to be with them in the country. The place was filling up. And it must be owned that this sudden population of Broadway was, from the start, more practical than romantic; in fact everything these artists did first had the cold simplicity of business logic. Broadway was made for an illustrator's library, with so many useful models of antiquity, with Stratford-upon-Avon so handy for Shakespeare reference, with such a perfect and long-established balance of architecture and nature—"Everything is stone except the greenness," James noted—none of which was available in America. Abbey, Millet and Company descended on Broadway at the precise and highly lucrative moment when American taste for literary illustration was turning voracious. *Harper's* and *Scribner's* magazines could not buy enough. The new occupants of Broadway incontestably had the edge on their American col-

leagues. In short, Broadway was immensely useful not just for library work—"Everything in it is convertible," James added—but for livelihood.

The influx continued. Where biology left off, the calendar took over. August was the month to vacate London, and those who did not come to work came to watch. Soon it was as if the entire precinct of Kensington had emptied into Broadway. By the end of the month, when the actress Mary Anderson (1859–1940) came to Stratford to show the English what an American could make of Rosalind, a party of twenty-five trooped over to see her. Henry Harper and his wife came to supervise his contributors; Edmund Gosse, who represented the competition as *Scribner's* English agent, also came to have a look, with his wife and her sisters—all painters—one of whom came with her husband Alma-Tadema (and his daughters). And James simply could not keep away from the fruits of his handiwork. To all of them, Broadway was narcotic.

For Sargent, it was strangely potent. He arrived sometime during the second fortnight in August. Since Farnham House was full to bursting—the Millets, their two children (Kate and Laurence), Millet's sister Lucia (who cheerfully shouldered the duties of housekeeper, governess, and seamstress), and Abbey, with just enough room left over to squeeze in a few servants—Sargent took lodgings at the sixteenth-century inn across the green, the Lygon Arms (today a superior hotel). And yet he still reckoned he was the Millets' guest. "I practically live with them," he wrote to his sister Emily in Nice. "It is in their garden that I work." The generous holiday mood had its way with him. He presented a wonderful spectacle of energy unleashed, which gave the lie to any suspicion that he might be convalescing (and no one noticed at the time or remembered to record his bandaged head). Gosse had his pen held high for the purposes of recollection. He made scrupulous notes of the large figure of Sargent in full tilt at work in the garden: each morning the artist started a new canvas, working feverishly for a few hours spreading a thin layer of color which conveniently dried by the next morning, and the whole process would start again. Sargent's subjects mystified Gosse. There was no nonsense about selecting one view over another, hunting out a "good" place—a barn or a wall or a field, "nowhere in particular," Gosse remembered. It was an enterprise like a game of musical chairs and baffling to all the observers. Sargent "explained it in his half-inarticulate way," Gosse continued. "His object was to acquire the habit of reproducing precisely whatever met his vision without the slightest previous 'arrangement' of detail, the painter's business being, not to pick and choose, but to render the effect before him." Such simplicity was heresy, or perhaps worse—foreign. To students of the Pre-Raphaelites, it was a dangerous departure from trusted principles—an outrage. To Sargent, however, it was nothing more than a highly refined application of Carolus's fundamental instructions: paint what your eye tells you, not what your mind dictates. Sargent began his holiday in Broadway by returning, in a sense, to Boulevard du Montparnasse—an advance that traveled straight back to 1874—in an attempt to recapture what had been lost in the claustrophobia of the studio. The garden studio was an antidote.

Sargent's stop-and-go game threw into relief the comic absurdity of the assembly in Broadway. While he was kicking "conventional" practices about, Abbey, Millet and Company were on a steady march back in time, going precisely in a contrary direction. They put their minds to work, then their pens. But there was never the slightest trace of rivalry. Congeniality ruled. The free and easy mood put a high gloss of pleasure on the place. The domestic arrangements were equally untroubled. Everyone looked to Farnham House and to Lily Millet, whose benign, kindly rule was unendangered for years, until

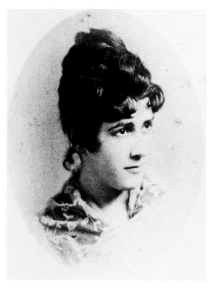

Fig. 2
Lily Millet. Courtesy private collection.

Abbey returned to Broadway with a wife in 1890. Work in the morning, entertainments in the afternoon: lawn tennis, walks, birthday parties—"Everything here seems so calm and cool and lazy," Gosse wrote. While children scampered about, the adults abandoned their own usual restraint. On one occasion the entire "colony" (as Lucia Millet called them) piled into Alfred Parsons's steam launch for a day on the river. A table running the entire length of the deck was loaded with a picnic luncheon—goose, ham, tongue, chicken, rabbit pie, pickled walnuts, cheesecake, tartlets, beer, and cider. Abbey played the banjo, everyone sang, and they then sat down to tea at 6:00 P.M. They disembarked at Pershore, strolled about, and returned home at sunset, ready for a cold supper. The birthday celebrations were similarly exuberant—card games, music, dancing. At one, James danced with Lucia Millet twice; the first waltz he said he had not danced for ten years, the second he said twenty. For Tessa Gosse's birthday (September 14), the children wore flower wreaths; for Lily Millet's (four days later), there were strolling musicians, lavish presents, dinner for twelve; and for Gosse's (on the twenty-first), Sargent and Lucia dined quietly with the Gosses in their rooms (on goose) before ambling over to the inn for cards, cakes, and gifts. "The boys"—Abbey and Millet, in Lucia's words—gave him a cane. Lucia made him a laurel wreath. And Sargent handed him a tall hat, which cockneys called a "Gossamer" or "goss."

The locals were somewhat bemused by all these unbuttoned, unrefined, and unadult activities. "Nothing we do scandalises the villagers," Gosse wrote to a friend (September 7, 1885). "Fred Barnard, with an enormous stage slouch-

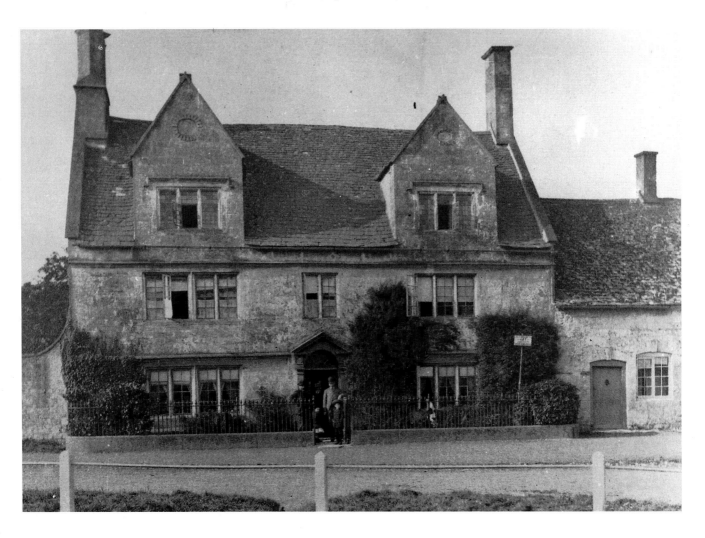

Farnham House, Broadway, c. 1895. Photo courtesy of Dr. C. C. Houghton, Broadway

hat over his shoulders, chased one of the Americans down the street, the man chased screaming all the time and trying to escape up lamp-posts and down wells. Not a villager smiled. Miss [Lucia] Millet, yesterday, in the middle of the village green, was reposing on a bench when the wood gave way and threw her into Fred Barnard's lap. Not a villager smiled. Whatever we do or say or hear or sing they only say, 'them Americans is out again.'" In the evening, Farnham House shook with music: someone sang ballads; Sargent, on the piano, hammered his way through the *Ring*; and the audience tried to doze.

For Sargent, Broadway was a short, stimulating burst of communal life, a triumph over the downtrodden feelings brewing within him. Paris seemed far away. And it was a terrible reminder of what he had left behind. The slow-working poison that had been released in his veins about a year before could not be ignored. He gave way to dark forebodings—he knew the holiday had to end; he knew he had to return to Paris. In his letters he put on a brave face, but in conversation the thin film of optimism evaporated. Sargent, Gosse recalled, "was profoundly dissatisfied with Paris . . . it will perhaps be believed with difficulty that he talked of giving up art altogether." Gosse, stupefied, asked what else the artist might do, and Sargent vacantly replied business, perhaps, "'or go in for music, don't you know,'" waving his hand in vague despair. Broadway had given him a luscious taste of freedom, making the future only seem worse. The garden experiments, consolidated in the picture later known as *Carnation, Lily, Lily, Rose* (Plate XIX), which he had begun in early September, only managed to make his studio a prison. He could not tear himself away. He used the excuse of the picture, but behind his reluctance lay the dread of Paris, the return to the Salon march.

He stayed a fugitive. Once the weather had made the garden inhospitable, he did leave, but for London. Sargent "*likes* London," James wrote in March (1886), warming his hands at the prospect of victory. In the middle of April, Sargent went to see his family in Nice to tell them that he was "moving his traps from Paris to London," as his father wrote to a brother in America (May 13, 1886), "where he expects to reside instead of Paris." The joint forces of Broadway and James had worked.

In the garden at Farnham House, Sargent had found the subject picture that had eluded him for years. It gave him the confidence to unroll his battle plans and make his advance on the Royal Academy. Success depended on the "big picture," as Lucia Millet called it. In the spring he sent fifty lily bulbs to Lucia to plant, twenty to be forced in pots. Unwittingly, he was entrenching himself deeper in the "colony." When he returned at the end of June, he was no longer a tourist but one of the tenants of the new, and much enlarged, Millet/Abbey establishment. The colonization of Broadway had been quick and mighty. Shortly before Christmas 1885, the Priory was acquired. It was a vast derelict property adjacent to Farnham House, ideal, after considerable restoration, as a studio. The summer idyll could be prolonged.

In March, Abbey and Millet took a seven-year lease on Russell House, and Sargent became a temporary partner from the summer. It was next door but one to Farnham House and, with the Priory, formed a triangle on the western edge of the green. It was much larger than Farnham House, littered with supplementary buildings in the garden, and was house and studio combined. During the four months prior to Sargent's tenancy, Russell House had been subjected to vast alterations, rendering it into something like a cross between a toffee-box illustration and a jumbo playroom. It was likened to a boys' school or the incarnation of one of the householders' precise illustrations. But whatever it was, people could not stay away. The summer of 1886 was a more densely

populated repeat of the year before. At the height of the season, Lucia counted twenty-two adult tourists and fourteen children scattered among lodgings or the inn. And the list of callers was enormous.

Russell House *was* got up to be an attraction, its make-up a little self-conscious, heavy, and wonderful. The masters of detail had done their job well, more mindful of effect than comfort. Licorice-colored oak furniture was moved in to complement the solid walls and the floors worn by centuries of use. The rooms were dark, fragrant with the smells of wood smoke, lamp oil, beeswax, and flowers. The ladies dressed for the setting, in period costumes or wispy gowns, so as not to break the spell of age. There were rare concessions to modernity: one of the small sitting rooms was hung with white material embroidered in yellow, the furniture painted white; Lily Millet's small sitting room was decorated with two paintings by Sargent (her unfinished portrait and *Girl with a Sickle* [Plate XVII]). And the post was collected every afternoon at five o'clock. The entire house was overhung with a thin veil of an undisturbed dream.

The garden was even more spectacular than the house and just as romantic, an entertaining duet of buildings and landscape. A gazebo, an ancient brick wall trailing off into the distance, a small machicolated tower with greenhouse, a flight of stairs lost in overgrowth, an orchard, a lily pond, and an admirably smooth tennis lawn filled the land. A peacock strutted across the lawn, and two rams meandered through a small woodland. Lily Millet had made the garden into a glorious show: long rose beds, white marigolds, vast scarlet poppies

Russell House, Broadway, c. 1877. Photo courtesy of Dr. C. C. Houghton, Broadway.

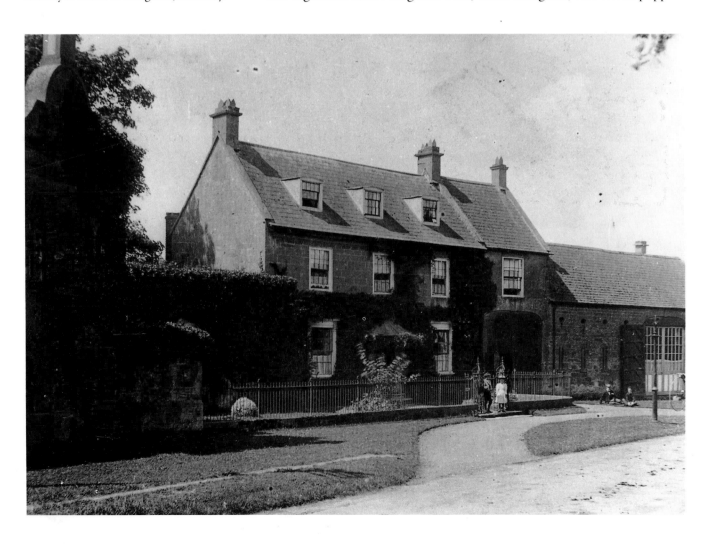

(which all the painters found intolerably unpaintable), hollyhocks, as well as Sargent's tall lilies. The scent of flowers was heavy, the colors blazed: the garden lived up to the storybook ideal of an English garden, playing its part in the Elizabethan illusion in which Abbey and Millet felt so at home. It was also a slightly absurd backdrop to the bustle that was re-enacted for a second summer.

The Russell House summer made the high cockalorum at Farnham House look like a tentative rehearsal for fun. Sargent still executed his deft "musical chair" routine, this time in luxurious surroundings, again enlisting tourists for models, but his slow installments on *Carnation, Lily, Lily, Rose* evolved into a prominence that became the focus in a set piece that epitomized the look and atmosphere of Broadway. Behind the scenes, the stage crew had been very active, keeping the props (lilies) in prime condition, the costumes (the models' white smocks) in perfect repair, the spectators at a distance, and everything in readiness for the crucial minutes when Sargent declaimed his lines: Late afternoon. Gosse, in knickerbockers, sits with his wife watching tennis (when not actually partnering Sargent in doubles). The Russell House standard of tennis is high, but not frighteningly high. Gosse's sister-in-law, Mrs. Williams, plays well; Edwin Howland Blashfield (the American painter, 1848–1936, who had vaguely known Sargent since 1871, spent most of the summer at Broadway) has a devilishly wicked serve; Sargent moves with amazing speed across the court and is particularly fiendish at the net; Millet is also swift, but Abbey is swifter; Alma-Tadema is comically awful, roaring with laughter at his mistakes. There is a lot of noise rising from the tennis lawn. Closer to the house Lucia presides over the tea table, doling out cakes and bread and butter. Frederick Barnard limps about on his sprained ankle (which had threatened to keep him, his wife, and his daughters—Sargent's models— in London). Children run back and forth. The peacock makes chase. Over by the gateposts James talks to Mrs. Blashfield, who is consumptive and stands on a small plank of wood to keep her feet dry. Around 6:30—the exact moment varied, getting earlier as the summer wears on—Sargent drops his racket, strides over to the studio, emerges with his easel and canvas, and sets them up in the exact spot he has occupied for weeks. He calls Dorothy and Polly Barnard, who are positioned amid the lilies and the lanterns. All three wait for the precise moment when the light is correct for resuming work. To keep them still, Sargent bribes the girls with sweets. Then, suddenly, painting begins, at a breakneck speed (Fig. 3). The tennis players have broken off their game to watch. So have the others. The light slowly fades, useless. It is now just coming on to seven o'clock. The guests disperse. Sargent lugs the canvas back to the studio, examines what he has done, and invariably scrapes clean the most recent addition, ready to start all over again tomorrow. In a few hours, everyone reassembles in Abbey's studio.

The mammoth old barn had been converted to Abbey's specifications, which were in concert with every novelist's idea of an artist's studio. His furniture from London was moved in, with his enormous store of costumes, props, wigs, and musical instruments. The room, large as it was, was packed. It was his by day, and by night it was turned over for the next episode in the set piece. The gaslights were turned up, and the games began. Mrs. Blashfield read palms—"'Oh yes, a fine philistine hand,'" James said, repeating her verdict. At the long refectory table in the center of the room, a game of poker was under way at one end; at the other a miscellaneous selection of drawings were being leafed through. James lectured on Millais's work. Applause broke out for a *tableau vivant* of Raphael's cherubs. Sargent suggested a game of throwing

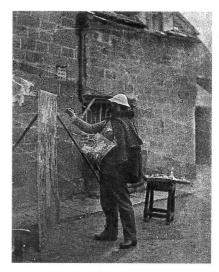

Fig. 3
John Singer Sargent Painting "Carnation, Lily, Lily, Rose," Broadway, 1886. Courtesy of the Harvard University Art Museum (Fogg Art Museum), gift of Mrs. Francis Ormond.

silhouettes behind a sheet and guessing the subject. Abbey opened the curtains on his costume store, and a few guests dressed up. And then real high spirits were let loose. Dancing. A Virginia reel; Alma-Tadema swept the floor in a hooped-underskirt. Millet tested the trombone. When Abbey finished cutting out James's silhouette (to add to the frieze of habitués around the walls), he tortured one of the harpsichords. Alma-Tadema's daughter played the guitar. Sargent went to the piano to partner Lily Millet in a four-hand arrangement of *The Mikado*, singing all the parts, or, less entertaining, returned yet again to the drone of Wagner. (It seemed as if the strong medicine of Bayreuth had only made Sargent's illness worse—and expanded his repertoire to *Parsifal*.) About midnight people began to drift away.

Sargent's monument to Broadway was ready for the Royal Academy in the spring of 1887, after nearly two years' work. When *Carnation, Lily, Lily, Rose* was unveiled and the public cheered and critics nodded sagely, Sargent could sigh with relief. The old campaign imported from Paris seemed to lurch back into operation. The picture did for his reputation in London what *El Jaleo* had done in Paris—he had served notice that he was more than a portraitist, that he could get into the Academy without being a sitter's toady. He appeared to have recouped all that he thought he had lost three years before. Thus restored, he promptly traveled in another direction. He had not needed the reassurances the Academy willingly offered. In truth, his confidence was in place six months before the picture to Burlington House, as if he had learned too painfully the penalty of false hope in 1884. In autumn 1886, he signed the lease on a studio at 33, Tite Street—his career in London would not hinge on public or critical favor. And though the transition from Paris was by then complete, he had not received any encouragement; his reputation, especially as a portraitist, had scarcely budged an inch since he had arrived. But Sargent was taking a deliberate turn: he looked at the parallel tracks of his work from a different and more distant angle. The old Salon etiquette had advanced that far. He would no longer measure success in terms of a full order book. Henceforth, portraits would cease to carry the importance they had mistakenly acquired in 1884 and would be consigned to the unemotional discipline of employment. He no longer cared for the text of his old recitations, grown weak by having been borrowed first from Carolus, then by a decade of declamation. He took over the full responsibility of stage management; he had acted to others' rules long enough. He had finally escaped the annual tribulations of applying for public favor because he had caught his first real glimpse of independence. Broadway had given him the strength to make the move, and, thus invigorated, he retired to another course of tutorials. It was 1879 all over again, but this time it was his choice. The lectures of Velázquez and Hals were replaced by those of Monet.

Sargent's new-found liberty was only partial. Though the sudden bursts of "experiments" during the subsequent summers—in Shiplake and Henley (1887), in Calcot (1888), and again in Pershore (1889)—have given art historians a luxuriously upholstered playpen to frolic in, sending them reeling from Monet to Sargent and back to Monet, Sargent had not unaccountably slipped out of character. He was obeying an inescapable truth. When he opened the text entitled "Monet," he was in fact remaining true to his susceptibility to influence. Over the years, however, the virulence would subside.

The tentacles of Broadway's power were far-reaching and would undulate across the rest of his life. His summers in Calcot and Pershore, though hindered by deep anxiety over his father's health at one and mourning at the other, were in painting terms strangely in concert with those he had spent at Broadway: the garden studio, tempered by the run of the river in 1887, was

found and repeated. In time, such strong, specific echoes of Broadway had to decline, but they continued to be heard all the same. His rise as the chief portraitist of the Edwardian age began in Broadway, when Alma-Tadema generously directed Henry Marquand's crucial portrait commission over to Sargent. And the tremendous leap from that reluctant passage to Newport on September 17, 1887, to the production of mighty canvases for Chatsworth, Blenheim Palace, and Welbeck Abbey spanned the next two decades. His mistaken elevation to civic decorator in Boston also owed much to the subtle workings of Broadway because Abbey encouraged him to affix those acres of canvas and bas-relief on the walls and ceiling of the Boston Public Library by distorting the tantalizing novelty of the work to some higher wisdom. But most of all, Broadway helped Sargent to think about his career with a sobriety unattached to loyalty. Without the forbidding complexities of the murals to darken the future—the work stretched over three decades—Sargent could never have excelled as a portraitist. And without having acquired a taste for "experiment," he would never have embarked on the foolishness of those decorations, which contradicted every atom of his ability. Broadway served up that crucial element.

NOTE ON SOURCES

A detailed list of notes and sources would be cumbersome and unnecessary since the standard Sargent bibliography is well known. Yet those works to which specific reference has been made are as follows:

Evan Charteris, *John Sargent* (London, 1927).
————, *The Life and Letters of Edmund Gosse* (London, 1931).
Leon Edel, *Henry James: The Middle Years, 1884–1894* (London, 1963).
Henry James, *Letters, III: 1883–1895*, ed. Leon Edel (London, 1980).
————, *Letters*, ed. Percy Lubbock (London, 1920).
————, *Picture and Text* (New York, 1893).
E. V. Lucas, *Edwin Austin Abbey, Royal Academician: The Record of His Life and Work*, Vol. 1 (London, 1921).
Lucia Millet, unpublished letters (private collection).
Fitzwilliam Sargent, unpublished letter, Archives of American Art, Smithsonian Institution, Washington, D.C.
John S. Sargent's letter to Mrs. Mahlon Sands (private collection).
Joyce Sharpey-Schafer, *Soldier of Fortune: F. D. Millet* (Utica, N.Y., 1984).

The author would like to acknowledge the invaluable assistance given to him by Mrs. Joyce Sharpey-Schafer, Dr. C. C. Houghton, Mr. Kirk Richie (of The Lygon Arms), and Miss Donna Seldin.

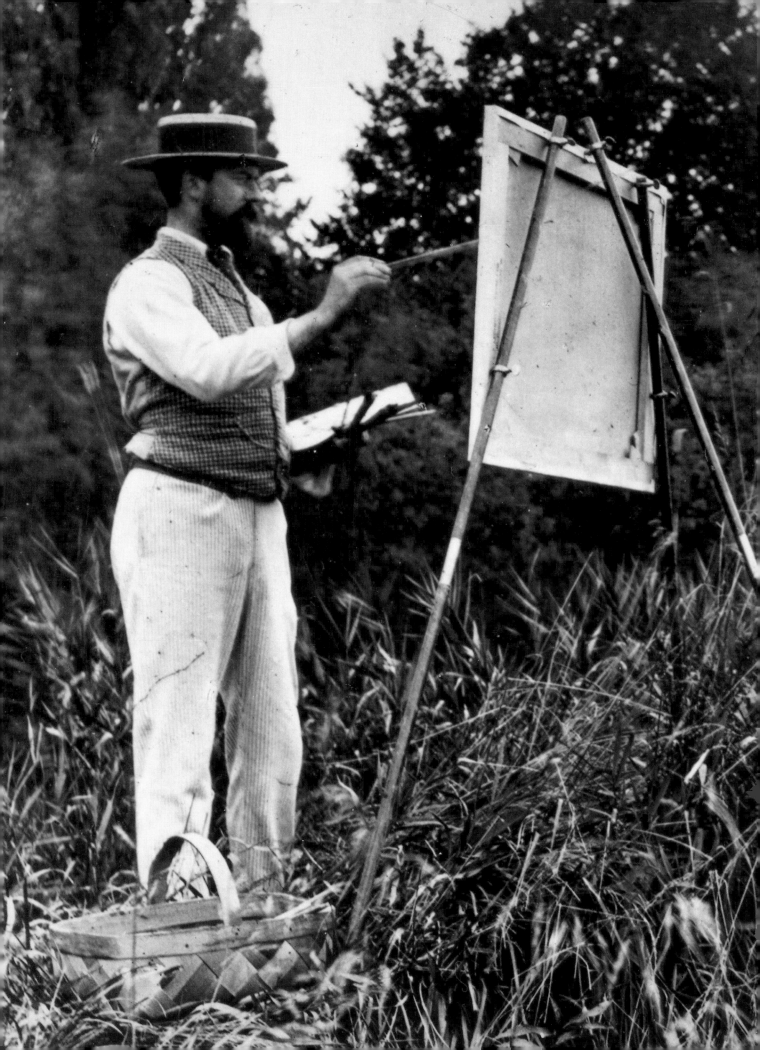

John Singer Sargent and "The New Painting"

by Warren Adelson

"What, then, have they produced? A color scheme, a kind of drawing, and a series of original views."

—Edmond Duranty,
"The New Painting" (1876)

The year 1887 was a turning point for John Singer Sargent. In that year he experienced two significant changes, one involving his career and the other his style of painting.

Sargent sailed for America on September 17, 1887. He had been invited to Newport by Henry Marquand, a wealthy American banker who commissioned Sargent to paint a portrait of his wife. Soon after his arrival and the successful completion of the Marquand assignment, Sargent's career in America as a portrait painter was launched. He received numerous commissions, and his exhibition at the St. Botolph Club in Boston in January 1888 drew rave reviews. He was hailed as a master, treated royally, socially lionized, and very well paid. He became established and successful. He had arrived. Just before leaving for America, Sargent's approach to painting evolved stylistically in a manner that was to mark his work for the rest of his life. The change took place at Giverny while Sargent was with his friend Claude Monet.

On August 19, 1887, Monet wrote to his fellow artist Paul Helleu: "I paint the figures in the open air as I understand them, treated like a landscape."[1] Monet wanted to paint the figure enveloped by light, to integrate the figure with the sky, the land, the water, the trees. He was obsessed by the idea of depicting objects defined not by their own form but by the light surrounding them. He wrote that he was "absorbed to the point of being almost sick. . . . It is nothing other than impossible."[2] It was more than the transitory effects of light, the time of day, the condition of the atmosphere that he was trying to paint. For Monet, immersion in the entirety of light, light as the integrating force, was the key to making flesh and earth, water and trees one.

In 1886, Monet painted *Essai de figure en plein air* (Fig. 4), in which his stepdaughter Suzanne Hoschedé is standing on a hillside. We see her from below, silhouetted against a bright blue sky. She holds a parasol. Mlle. Hoschedé has turned at this instant to face the painter. The wind ruffles her dress, blows her scarf, stirs the grass around her. Clouds whisk by in the sky. The figure is dematerialized as if dissolving into the air. The light shimmers. The parasol's green lining reflects on her face, the sunshade's shadow tinged with blue and violet. Her facial features are barely indicated. The yellow-green of the undergrowth sparkles on her dress, and bright white charges the entire surface.

In the following year, 1887, Monet painted *La Barque à Giverny* (also called *En Norvegienne*) (Fig. 5). The three Hoschedé sisters (Germaine, Suzanne, and Blanche) are shown fishing from a punt. The view is that seen from the artist's

Fig. 4
Claude Monet, *Essai de figure en plein air (Vers la droite)*, 1886. Oil on canvas, 40½″ × 36⅝″. Musée du Louvre, Galerie du Jeu de Paume, Paris.

Opposite:
Sargent painting at Fladbury (detail), 1889.
Photo courtesy of the Ormond Family.

bateau-atelier. (Monet had used a boat as studio more than a decade earlier while at Argenteuil, and earlier artists like the Barbizon painter Charles-François Daubigny had also made use of a floating studio.) In this painting, the water is perfectly still, allowing the artist to capture the reflected images of the girls, the boat with extended oars, and the vegetation behind. There is no sky, and the whole scene is suffused with an even, dense light. The backdrop of bushes serves as a curtain, a tapestry. The thick atmosphere, the closeness of the place, is palpable. Figure and landscape merge.

It was undoubtedly in 1887, too, that Monet's portrait was painted by his friend Sargent (*Portrait of Claude Monet*, Plate I). Sargent was the younger man by sixteen years. He had met Monet in 1876, and their friendship had grown. While visiting Monet at Giverny during the summer of 1887, Sargent also executed *Claude Monet Painting at the Edge of a Wood* (Plate II).[3] This crucial canvas "is not only an expression of their friendship, but a statement of artistic faith."[4] The picture is Sargent's affirmation of outdoor painting, a vote of confidence for *en plein air*. Sargent depicted Monet seated before his easel painting a landscape (Sargent's conception of a Monet). Mme. Monet is seated on the right, perhaps reading. (Ladies reading is a recurring theme in Sargent's work.) Her white dress billows around her, and she seems to hover over the grass. The delicate blue-violet shadows do not model or define form in any traditional way. Monet himself seems insubstantial, a figure that blends into the grass, the loosely held palette, the painted canvas. He is as much an apparition as a man. The backdrop here is a grove of trees with bits of sky peeking through. Sunlight illuminates the entire scene. There are no strong shadows; light envelops everything.

When this picture was painted, Sargent and Monet were the closest they would ever be as artists. Under Monet's influence, Sargent painted a series of oils in 1887 from his own *bateau-atelier*. They included ladies in punts with reflections in the water. And just as Monet had painted his stepdaughter standing on a hill and viewed from below, Sargent in 1887 painted his friend Judith Gautier standing high up on a dune, silhouetted against the bright blue sky (*Gust of Wind*, Plate III). Clouds blow by, her scarf moves in the breeze, her broad-brimmed hat reflects light and shades her face like a parasol.

This and the following two to three years saw the maturation of Sargent's Impressionism. But to understand what he accomplished during these years, we must look back to the origins of his artistic development, to an unlikely place: the studio of Charles Auguste Emile Durand, known as Carolus-Duran.

In 1874, Carolus-Duran was a stylish, slightly flamboyant, eminently successful portrait and genre painter. In that year, a shy, slender John Sargent, eighteen years of age, mounted the stairs of Carolus's studio and was greeted at the door by an American art student, James Carroll Beckwith. Sargent rapidly became the star pupil—he was the favorite of the master in a predominately foreign (American) student body. Carolus was remarkably forward-looking in his teaching methods. Unlike Gleyre (who was eventually rejected by Monet, Renoir, and Bazille), Gérôme, and others of the Beaux-Arts tradition, Carolus-Duran's emphasis was not on the rigid study of the antique and stringent adherence to draftsmanship. Instead, Carolus emphasized the definition of form by means of values—gradations of light and dark tones. These values were to be put down broadly and rapidly—*au premier coup*. Through the use of lights and darks, one defined form, created images. Values and form superseded drawing. This was Velázquez's technique reinterpreted in modern terms, and this is what Carolus stressed.

Five years prior to Sargent's arrival, Carolus had made a sensation at the Salon of 1869 with his *Lady with a Glove*, "a portrait of compelling style and realism."[5] He was regarded as a modernist; his objective in painting was technical excellence and a strong sense of immediacy. He had no interest in the spiritual and social values espoused by Courbet, Millet, and other adherents to the school of social realism. He sought directness through accuracy of vision: "Search for the half-tones, place your accents, and then the lights. . . . Velázquez, Velázquez, Velázquez, ceaselessly study Velázquez."[6]

Carolus-Duran was a realist. He was also realistic. He saw that the road to success, fame, and fortune was the Salon. Recognition there meant public acceptance; rebuke was synonymous with failure. This opinion was hardly narrow or mean—it was a fact that most artists at the time had to face. The situation was best summarized in Renoir's remark to his dealer, Paul Durand-Ruel, in March 1881: "There are in Paris scarcely fifteen art-lovers capable of liking a painting without Salon approval. There are 80,000 who won't buy an inch of canvas if the painter is not in the Salon."[7] Manet sought Salon approval throughout his career and craved the red ribbon of the Legion of Honor.[8] Renoir, Monet, and others of the Impressionist group continued to submit works to the Salon, albeit intermittently after 1874.

The importance of the Salon was certainly impressed upon young John Sargent. He knew what he had to do. During his first couple of years as a pupil of Carolus, Sargent worked hard at painting and drawing the figure. He would be a successful portrait painter like his master. He attended the studio of Carolus-Duran during the day, took a class at the Ecole des Beaux-Arts from 5:00 P.M. to 7:00 P.M., and after dinner worked in the studio of Léon Bonnat from 8:00 P.M. to 10:00 P.M.[9]

We must note, however, that during these years there was much more to see and learn in Paris than could be found within the confines of the studio. Two of Sargent's paintings from this period make it evident that he was viewing and responding to works by a group of artists reviled in the press and ridiculed by the public: the Impressionists—notably Monet, Renoir, and Degas. The First (1874) and Second (1876) Impressionist Exhibitions were widely, if unfavorably, reviewed by the press and were the object of much public discussion. So was the auction sale of March 1875, a dismal attempt by Monet,

Fig. 6
John Singer Sargent, *Two Wine Glasses*,
c. 1875. Oil on canvas, 18″ × 14½″.
The Marchioness of Cholmondeley.

Renoir, Morisot, and Sisley to sell their works. These events were not missed by Sargent. Certainly, he saw the Second Exhibition, if not the First. His master, Carolus, was well acquainted with Manet and Monet. Manet, perhaps seeking a share of Carolus's success, painted a portrait of the famous society painter in 1876 while summering with the collector Ernest Hoschedé at Montgeron, outside Paris.[10] Nine years earlier, Carolus had painted a stunning portrait of Monet inscribed "à son amis [*sic*] Monet" (Musée Marmottan, Paris).

In the summer of 1875, Sargent joined Carolus and some other students to paint in Grez, a village in the Barbizon. From the style of paintings he produced in this period, it is clear that Sargent not only knew the works of the Impressionists but that he was directly influenced by them. At Grez he painted *Two Wine Glasses* (Fig. 6), a small but revealing canvas.[11] The intimate mood, the informality of the scene, the dappled, sparkling light, and the thick strokes of paint are hardly the traditional Barbizon technique of the academician painting outdoors. In the same year, Sargent painted *Resting* (Fig. 7), another small but telling example of his early Impressionism. The subject of a young woman outdoors resting or reading or simply gazing is common to Monet, Renoir, and Manet during this period.[12] The flickering light, bright touches, and broad brushwork were not learned or even seen in Carolus's studio.

The elderly Monet recounted his first meeting with Sargent in a charming letter (printed in the Sargent biography of 1927 by Evan Charteris):

> I met Sargent and Helleu for the first time at Durand-Ruel [the Gallery] Rue de la Paix around 1876. Sargent rushed up to me while saying, "Is it really you, Claude Monet?" Then he invited me to dine at the Café de la Paix; he had many friends [fellow students] with him. I directed them to the Café Helder, and asked for a private room there. Unfortunately there were many of my paintings there. I was disturbed upon entering, being concerned that Sargent and the others would think that it was because of my paintings that I invited them to the Café Helder.[13]

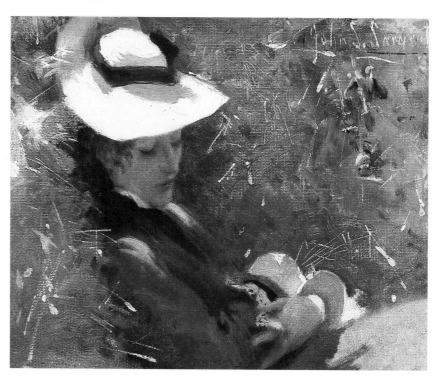

Fig. 7
John Singer Sargent, *Resting*, c. 1875.
Oil on canvas, 8½″ × 10½″. Sterling and
Francine Clark Art Institute,
Williamstown, Massachusetts.

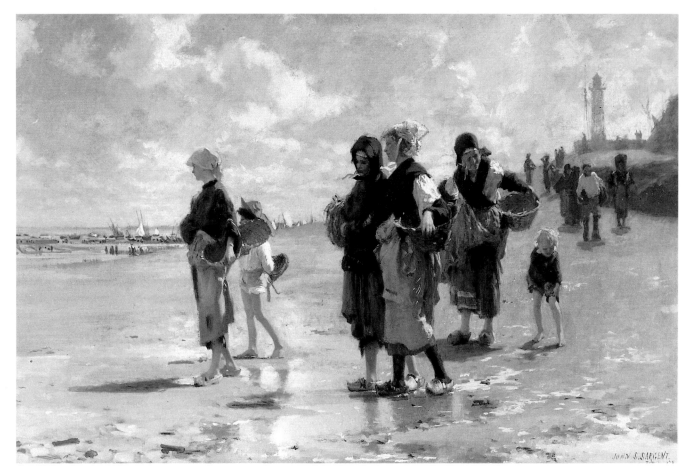

Fig. 8
John Singer Sargent, *The Oyster Gatherers of Cancale* (also called *En Route pour la Pêche*), 1878. Oil on canvas, 31″ × 48½″. In the collection of the Corcoran Gallery of Art, Washington, D.C.

Paris gave Sargent his first view of the radical work of the Impressionists. But beyond that, Paris provided a diverse pool of contrasting influences for the young artist. Over the next few years, Sargent was affected by many of the prevailing currents: he admired Camille Corot (1796–1875), who had just died in February 1875, Gustave Courbet (1819–1877), Jules Bastien-Lepage (1848–1884), Eugène Boudin (1825–1898), and James A.M. Whistler (1834–1903).

Sargent's first major out-of-doors subject was painted in the studio from sketches made in Brittany in the summer of 1877. *The Oyster Gatherers of Cancale* (Fig. 8) is a bright and luminous beach scene. The sky and water are painted more in the manner of Boudin than that of his protégé Monet. However, the arrangement of the figures is processional, friezelike, and formal in contrast to the milling crowds of Boudin's beach scenes. Sargent's figures are solidly constructed with a fine sense of values, no doubt pleasing to M. Duran. The painting is a synthesis of contemporary sentimental genre painting and the plein-air effects of Boudin and the Barbizon school. Light doesn't flicker here—it glares. The painting itself, done in the studio, is far brighter and more lively than its preliminary oil sketches executed *in situ*.

Sargent was to experiment with another kind of light in the following two years: twilight, a time beloved by Corot, "when light is tempered, when nature wraps itself in a transparent veil that softens contrasts, hides details and simplifies lines, planes, the essential forms, and colors."[14] In the summer of 1878, Sargent, age twenty-two, spent August on the island of Capri. Rosina, a local girl, modeled for Sargent in several paintings done at this time. In *Capri Girl*, the solidly constructed, exotically posed young woman is seen from behind, dramatically entwined in a gnarled tree and artfully incorporated into the landscape. This tonal integration of figure and landscape is related to the

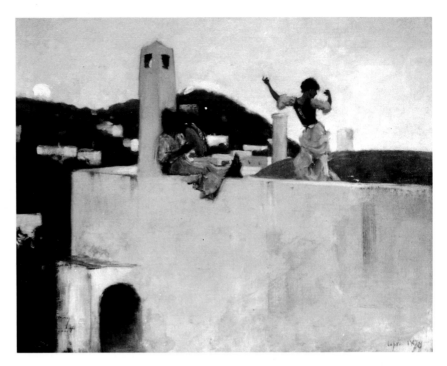

Fig. 9
John Singer Sargent, *Capri*, 1878. Oil on
canvas, 20″ × 25″. Private collection.

works of Bastien-Lepage (cf. *Joan of Arc*, Metropolitan Museum of Art, New
York). The romantic mood and evanescent effect of twilight are reminiscent of
the works of Jean-Charles Cazin (1841–1901), Corot, and others of the Barbi-
zon tradition. In *Capri* (Fig. 9), Sargent painted Rosina again at twilight on the
roof of the Marina Hotel. The painting is unified by a pervasive haze of cool
blue. The soft whites, lavenders, and greens shine through the haze. The
technique of unifying the scene with a cool palette and even light throughout is
used by the artist the following year (1879) in *In the Luxembourg Gardens* (Fig.
10). The subject here is not exotic: men and women strolling through the
garden at dusk. This is more an impression, a quick glance at figures passing by.
The light has now become even more diffused and smoky, and the attitudes of
the figures are casual, informal.

Individuals with barely discernible features, their station in life recogniz-
able only by their dress, enjoying themselves in a public garden—such scenes

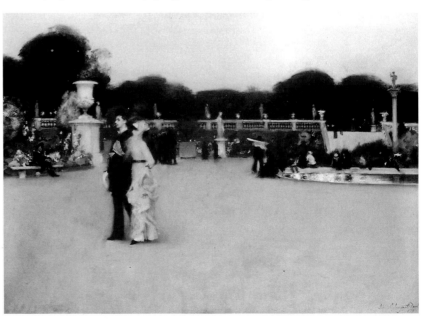

Fig. 10
John Singer Sargent, *In the Luxembourg
Gardens*, 1879. 25½″ × 36″. Philadelphia
Museum of Art, John G. Johnson
Collection.

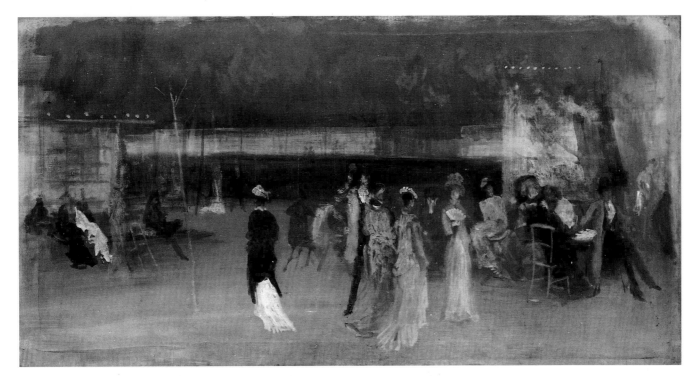

Fig. 11
James McNeill Whistler, *Cremorne Gar-
dens, No. 2,* c. 1872–1877. Oil on canvas,
27″ × 53⅜″. Metropolitan Museum of Art,
John Stewart Kennedy Fund, 1912 (12.32).

were becoming a common subject for modern painters. Degas, Manet, and
Renoir saw the role of the modern artist as one of *flâneur,* "the impartial,
nonjudgmental observer of contemporary life."[15] This was a view shared by
Whistler in the 1870s. The vague, amorphous figures that float by in Whistler's
Cremorne Gardens, No. 2, 1872–1877 (Fig. 11), provide "a glimpse of the ano-
nymity of modern life."[16] Whistler's picture, of which there are several ver-
sions, relates to Sargent's *In the Luxembourg Gardens* not only in subject matter
but also in the stagelike setting, the delicate brushwork, and the evanescent
light. In both paintings, the artist is the unseen observer, the "detective,
shadowing his subjects."[17] As Baudelaire described him in "The Painter of
Modern Life" (1863):

> For the perfect *flâneur,* for the passionate spectator, it is an immense
> joy to set up house in the heart of the multitude, amid the ebb and
> flow of movement, in the midst of the fugitive and the infinite . . . to
> be at the centre of the world—such are a few of the slightest pleasures
> of those independent, passionate, impartial natures which the tongue
> can but clumsily define. The spectator is a *prince* who everywhere
> rejoices in his incognito.[18]

As modernists, Manet, Degas, Renoir, and Caillebotte painted the street
life of Paris in pictures that "focus upon implied relationships glimpsed at close
hand, as individuals arrange their assignations."[19] In an important review of
the Second Impressionist Exhibition of 1876 entitled "The New Painting:
Concerning a Group of Artists Exhibiting at the Durand-Ruel Galleries,"
critic Edmond Duranty spoke specifically about Degas and his subject mat-
ter—the depiction of contemporary life: "It was necessary to make the painter
leave his skylighted cell, his cloister . . . and to bring him out among men, into
the world. The idea was to take away the partition separating the studio from
everyday life. We need the particular note of the modern individual, in his
clothing, in the midst of his social habits, at home or in the street. By means of a
back, we want a temperament, an age, a social condition to be revealed;
through a pair of hands, we should be able to express a magistrate or a

Fig. 12
John Singer Sargent, *The Sulphur Match*,
1882. Oil on canvas, 22¹³⁄₁₆″ × 16⅜″.
Jo Ann and Julian Ganz, Jr., Collection,
Los Angeles.

tradesman; by a gesture, a whole series of feelings. . . . They [the Impressionists] try to render the walk, the movement, the tremor, the intermingling of passerby" just as they have tried to capture the various effects of light.[20]

During several extended visits to Venice over a two-year period, Sargent executed a series of remarkable paintings of ordinary Venetian life. In 1880, having just returned from an exhilarating trip to Spain where he studied Velázquez at firsthand, Sargent was strongly influenced by the master's dark palette, dramatic light, and complex interior compositions. He had also visited Holland, where he was much impressed by the genre subjects, receding perspectives, and subtle light of Vermeer, de Hooch, and other "little masters." (He would have seen works by the seventeenth-century Dutch painters at the Prado as well.)

Sargent used these various pictorial devices in his rendition of contemporary life. In *The Sulphur Match* (Fig. 12), a young, exotic woman precariously tips back in her chair while gazing idly at her companion, a dark young man who lights a cigarette. This is a brief moment in time—a blink of the eye, and the event would be missed. The composition is not balanced but is slanted diagonally to the left. The figure of the man is cut off on the left side. The shadowed wall closes the space behind the two figures. The light is suffused and dramatized with chiaroscuro effects. This corresponds neatly to Duranty's description of a modern composition.[21]

It is revealing to compare this painting to Degas's *L'Absinthe* (Fig. 13) of 1876, which Sargent saw in the Second Impressionist Exhibition. In Degas's painting, the woman gazes dully, eyes unfocused, facing in the general direction of the viewer. Her companion is sitting beside her, leaning forward on the table and looking away to the right. They are seated on a diagonal, weighted to the right, balanced by the tables in the foreground. The tables are cut off, as is the man's knee at the right. The shadowed wall behind closes the composition. The handling of the two paintings is considerably different: the Degas broadly stroked in a flat, Impressionist manner; the Sargent broadly but academically rendered in values, creating a sense of volume. Both paintings are nearly

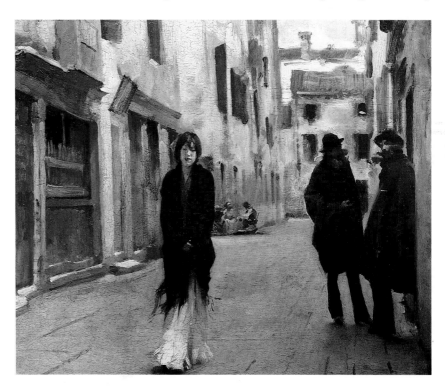

Fig. 14
John Singer Sargent, *A Street in Venice*,
1882. Oil on wood panel, 17¾″ × 21¼″.
National Gallery of Art, Washington, D.C.,
gift of the Avalon Foundation.

monochromatic in palette, using muted, subtle variations of browns, ochers, and reds in a rich color harmony.

The figure groupings and the compositions clearly relate, but the mood and technique differ. Degas depicts a bourgeois scene: the people are two specific, disheveled types. Sargent captures a real event but heightens it dramatically. In a sense his figures are players on a stage, acting out some more generalized truth. We feel that the scene means more or something other than what we see. Sargent took an ordinary event, composed it in a "modern" fashion, and heightened its meaning by dramatic light effects.

The effects are also seen in his *A Street in Venice* (Fig. 14), in which a young woman walks down a street while two men standing near a doorway watch her pass by. The woman's eyes are downcast as she approaches us, and the light catches her cheek as it does the cheek of one of the dark men glancing at her. In the middle ground are a man and a woman, perhaps fruit vendors. Degas painted street scenes in which men and women, children, and animals pursue their daily occupations—a slice of bourgeois life in Paris, observed neutrally by the *flâneur*-artist. Sargent adapted the subject of the street scene to his own ends. There is a sense of mystery in his painting; the diffused lighting creates a dramatic event, though unspecified in character. We don't know what is going on. It is all implication, suggestion.

Just as Degas had chosen laundresses and milliners, Sargent focused on a local cottage industry in Venice—that of stringing beads. In *Venetian Bead Stringers* (Fig. 15), the fourth wall of the room has been cut away, and we see three women engaged in their task. They are oblivious to us. The mood is serene, but a beam of light and a staircase at the rear left of the room as well as a darkened archway to the right add a sense of mystery and drama to what is ostensibly an everyday scene. The women's gestures are sure, accurate. Whether they gaze at one another or focus on their work, there is a sense of concentration. The hands of the woman to our left deftly arrange the beads in a manner similar to the sure sense of gesture in Degas's *At the Milliner's* of 1882

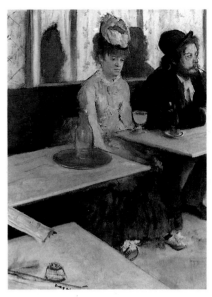

Fig. 13
Edgar Degas, *L'Absinthe,* 1876. Oil on canvas, 37″ × 27½″. Musée du Louvre, Paris.

Fig. 15
John Singer Sargent, *Venetian Bead Stringers,* 1881. Oil on canvas, 26⅜″ × 30¾″. Albright-Knox Art Gallery, Buffalo, New York, Friends of the Albright Art Gallery Fund, 1916.

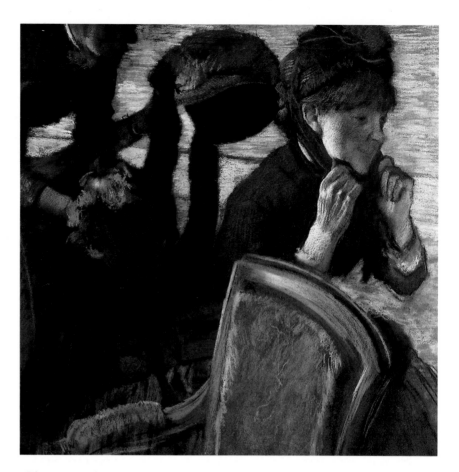

(Fig. 16). In this picture, a woman arranges her new hat, and a saleswoman, intent on her job, hands her two others. The same sense applies in *Laundresses,* 1882 (Norton Simon Collection, Los Angeles), in which one girl irons a shirt in a strained, athletic pose while the other yawns and stretches: a brief moment captured. Degas's workers are commonplace people. Sargent's are real, but they are also actors on a stage, performing a role drawn from contemporary life.

These Venetian scenes were modern pictures, and Sargent exhibited them accordingly. *A Street in Venice* was not offered to the Salon but was exhibited along with two portraits in 1883 at the Société Internationale de Peintures in Paris. One of the portraits was the stunning bravura sketch of his childhood friend Vernon Lee, who had changed her name from Violet Paget (Fig. 17). A contemporary reviewer exclaimed: "Mr. Sargent reveals himself as an impressionist of the first rank."[22]

The year 1883 proved to be a critical one for Sargent. During the previous six years he had met with success at the Salon, winning medals and favorable critical acclaim for such works as *The Oyster Gatherers of Cancale, Madame Ramon Subercaseaux,* and the highly theatrical *El Jaleo.* His reputation was growing. However, portrait commissions were slow in coming—far too slow for his liking. The desire for a Salon success was common to all artists. Monet had achieved it in 1866 with *Camille* (also called *La Femme à la robe verte*); Carolus in 1869 with *Woman with a Glove;* Manet in 1873 with *Le Bon Bock;* and Renoir in 1879 with *Madame Charpentier and Her Children.* Why, Sargent wondered, should he not paint a stunning picture and gain a measure of recognition?

The execution, exhibition, and ensuing condemnation of *Madame X* (the sitter was Mme. Pierre Gautreau, née Virginie Avegno [1859–1915]) are well

known. However, his other work at this time (1883–1884) has barely been considered. While struggling with the portrait *Madame X*, Sargent was painting some interior scenes and landscapes that were transitional in his *oeuvre*. They propelled him into Impressionism.

Impressionism was far more than the plein-air painting of Corot, Courbet, Jongkind, and Boudin. It was a great step forward, a new method in the representation of nature. In fact, it was a new way of seeing. It rejected the objectivity of realism and selected one element—light—to interpret all of nature.[23] This depiction of light required a new palette, a higher key. The careful observation of colored light meant doing away with dark (black) shadows, which did not exist to the Impressionist eye. Local colors were ignored to achieve the general atmospheric effect. The color painted was not what it was supposed to be (green grass, blue sky, etc.), but the many subtle hues that the Impressionists saw.

The manner of paint application changed as well. By applying paint in perceptible strokes, the outlines of objects blurred and those objects merged with their surroundings. In this way, one color could be placed next to another without degrading it, enriching the color effects. Moreover, the multitude of touches and the contrasts among them suggested activity, vitality, and the scintillation and movement of light. The vivid strokes seemed to retain the rapidly changing aspects of light. Form and perspective, traditionally defined by value and line, were now defined by the vibration and contrast of color. So much for *les valeurs* of Carolus. By the prevailing judgment of the mid-1870s, this was more than high-key, bright outdoor painting. This was heresy.

Public opinion of Impressionism in the early 1880s was far better than it had been in the mid-1870s. On March 1, 1882, the year that Sargent exhibited *El Jaleo* at the Salon Durand-Ruel, the Seventh Impressionist Exhibition opened on the rue St. Honoré. It was the most consistent and homogeneous of all the Impressionist exhibitions. It was devoted to pure, brightly colored landscape and figure painting. The artists shown were Monet (thirty works), Pissarro (thirty-seven works), Renoir (twenty-five works, including his recent masterpiece *Le Déjeuner des canotiers*, a luncheon scene), and Sisley, Morisot, Gauguin, Caillebotte, Vignon, and Guillaumin. Degas and Cassatt declined to exhibit. The press was far less aggressive. There were some favorable notices and even a few buyers. Gone was the venomous criticism of the 1870s. Furthermore, the Salon itself was showing the impact of Impressionism that year. "The general trend toward brighter colors became ever more obvious."[24] Critic Henri Houssaye summed up the prevailing attitude in his Salon review: "Impressionism receives every form of sarcasm when it takes the names Manet, Monet, Renoir, Caillebotte, Degas—every honor when it is called Bastien-Lepage, Duez, Gervex, et al."[25] Clearly, there was a change in attitude.

Moreover, the Impressionists were getting further exposure from Durand-Ruel. The dealer proceeded with a series of one-man exhibitions, then an uncommon and not especially popular type of show. The 1883 schedule was as follows: January–February: Boudin; March: Monet; April: Renoir; May: Pissarro; June: Sisley. Sargent could not have missed these shows. To promote his artists, Durand-Ruel organized a small Impressionist exhibition in London during the summer of 1882 as well as a larger one in 1883 (April–July) in New Bond Street. Sargent exhibited *El Jaleo* at the Fine Arts Society in London in July 1882 and *The Pailleron Children* in that city the following July. Even if he had wanted to avoid Monet and the others, he could not have.

While visiting his family in Nice, Sargent painted his younger sister Violet in *The Breakfast Table* (Fig. 18). The young woman reads her book, holding a

Fig. 17
John Singer Sargent, *Vernon Lee*, 1881. Oil on canvas, 21⅛″ × 17″. Tate Gallery, London.

Fig. 18
John Singer Sargent, *The Breakfast Table*,
1884. Oil on canvas, 21¾″ × 18¼″.
Fogg Art Museum, Harvard University,
Cambridge, Massachusetts, bequest of
Grenville L. Winthrop.

piece of fruit in both hands. This isn't breakfast—it is sometime after or perhaps well before. There is no evidence of other family members being present, though the table is set. It is a peaceful, quiet time of day. As in the Venetian pictures, we feel the mood rather than understand the story. The flowers on the table are brushed with the stroke and facture of Manet, and the silver pieces on the table and sideboard glint and create a dappled effect that enlivens the surface of the canvas. The gesture is momentary, and the composition is cropped. The spirit is not Venetian mystery—it is one of clear light and direct impression.

The theme of young women at a table was one captured by Manet in the late 1870s (cf. *The Plum*, 1877, National Gallery of Art, Washington, D.C.). Sargent was well aware of Manet's pictures. Trevor Fairbrother rightly suggests the direct influence of Manet on *The Breakfast Table*.[26] The same theme of figures casually seated at a table strewn with glassware and fruit or flowers was also used by Renoir in such works as *The Cup of Chocolate* of 1879 (private collection), *The Rowers* of 1880 (The Art Institute of Chicago), and the grand *Le Déjeuner des canotiers* of 1881, which Sargent viewed at the Seventh Impressionist Exhibition in 1882. It was in that year that he and Manet won medals at the Salon.

Stepping out of doors, this spirit of fresh air and direct impression is keenly felt. In two landscapes of this period—*House and Garden* (Plate IV) and

Nice (Plate V)—we sense this vitality. Both paintings depict an orchard in front of the same country house. The grass, white building, and open sky set off the light-filled trees. The brushwork is vigorous; it has a nervous energy that we have not yet seen in Sargent's work. It is not just the rapidity of the brushwork. It is the manner in which the paint is applied in short, staccato strokes, as though the canvas were not painted but attacked. The palette is muted, as in *Thistles* (Plate VI), another canvas of this period. The color sense still relates more to his work of the late 1870s. A higher key was to follow.

Other Impressionists were on the Côte d'Azur that year. Monet and Renoir were near Nice later in 1883 "in search of new motifs."[27] Monet had been particularly taken with the beauty of the Mediterranean landscape and planned to return the following year. In 1883 he moved to Giverny. Berthe Morisot was also in Nice and, according to a letter to her brother on August 20, 1883, had just missed seeing Sargent. She had attempted to gain his support for the next Impressionist Exhibition, and asked her brother if he had sent Sargent the notices about it. Apparently, Sargent had said many flattering things about her. She was aware of him, saying, "He is having a great success and is a pupil of Carolus-Duran."[28]

In the following year, 1884, Sargent went to Lavington Rectory near Petworth in Sussex, where he painted a portrait of Mrs. Albert Vickers. He also painted an interior, *A Dinner Table at Night*, also called *The Glass of Claret* (Fig. 19). The composition is again cropped—Mr. Vickers is cut in half.

Fig. 19
John Singer Sargent, *A Dinner Table at Night (The Glass of Claret)*, 1884. Oil on canvas, 20¼″ × 26¼″. Fine Arts Museum of San Francisco, Athol McBean Foundation.

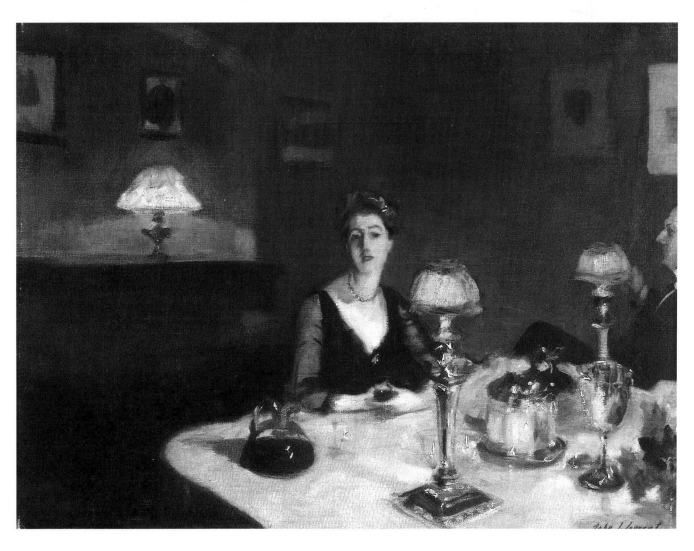

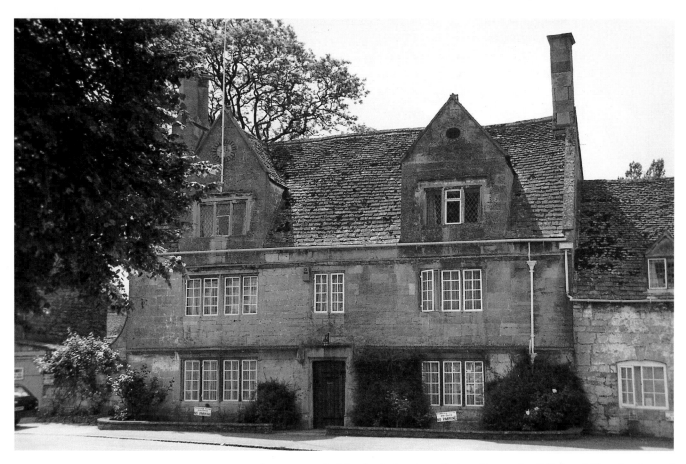

Farnham House, Broadway, 1985.
Photo courtesy of Jan P. Adelson.

Sargent reveled in depicting lamplight effects: the full-faced illumination of Mrs. Vickers holding her glass of wine, the soft light of the lamps that spreads through the opulent room. The silver, flowers, lamps, pictures on the walls, and other objects are even more broadly painted than those in the Nice interior. The sketchiness and broad handling as well as the contemporary people and the sense of the moment captured place this painting and the artist firmly in the Impressionist camp. The picture was exhibited at Galerie Georges Petit's Exposition Internationale in 1885, with works by Monet, Renoir, and other modern painters. A third picture executed at Petworth, *Garden Study of the Vickers Children* (Plate IX), shows Vincent and Dorothy Vickers in the garden. The lawn is tipped up to serve as a backdrop for the children and the potted lilies. The flowers and the children are brushed broadly and thickly, with the same rich texture as the interior scene showing their parents. The tableau of the children watering the lily is contrived and suggests the sentimental figurative works of the English narrative painters. The genre quality marks this as a transitional painting. It is nonetheless modern in composition, facture, light, and handling. Clearly, it foreshadows the following year's effort.

In winter 1885, Sargent returned to Paris. According to Charteris, he saw a great deal of Degas, Renoir, Sisley, and Pissarro, "but Claude Monet was the artist of all others with whom he was on the most friendly terms." He met with them often, usually at Durand-Ruel's gallery. He was also friendly with Ernst-Ange Duez, whose portrait he painted (Plate XI), Roger-Joseph Jourdain, and other followers of Manet. Sargent's career as a portraitist seemed to be at a standstill. The repercussions of the *Madame X* scandal had been more profound than he had expected. Commissions were not to be found. Clearly, the solutions were not in Paris. America was still unknown to him. In early 1885, he went to England, as much by default as by design.

Sargent's introduction to the village of Broadway in the Cotswolds was accidental. During a summer boating trip on the Thames with the American artist Edwin Austin Abbey, Sargent was injured while swimming at Pangbourne. Abbey insisted that Sargent come to Broadway to recuperate. Thus, in the late summer of 1885, Sargent registered at the Lygon Arms, a sixteenth-century inn at the village of Broadway. Abbey and his friend Frank Millet, another American painter, had rented Farnham House, a charming cottage facing the green. They were encamped there with their families and numerous friends, many of whom Sargent knew. Among them were the writers Henry James and Edmund Gosse (Plate XV), and the painters Alfred Parsons and Frederick Barnard. The atmosphere was not simply congenial—it was familial. Sargent was among friends, artists and writers who were wholly sympathetic to him. Moreover, the mood was joyous. The atmosphere was like that of a summer camp. During the day, the artists and writers went about their usual occupations. At night, there were conversation, music (a joy to Sargent, who excelled at the piano), theatrical entertainment, and, all in all, a happy time. He was free to do as he chose, and, naturally, he chose to paint.

According to Gosse, Sargent painted every day in a most unorthodox fashion:

He was accustomed to emerge, carrying a large easel, to advance a little way into the open, and then suddenly to plant himself down nowhere in particular, behind a barn, opposite a wall, in the middle of a field. . . . The other painters were all astonished at Sargent's never "selecting" a point of view, but he explained . . . his object was to acquire the habit of reproducing precisely whatever met his vision without the slightest previous "arrangement" of detail, the painter's business being, not to pick and choose, but to render the effect before him, whatever it may be. . . . This was a revolutionary doctrine, but Sargent was not moved.[29]

Sargent's excursions into the field may have seemed revolutionary or random to the English and American artists at Broadway, but in fact the process was not appreciably different from his technique of the past two years in Nice. *Home Fields* (Plate XIII) was painted at Broadway during this fall season. It is like *Nice* (Plate V). Both paintings have a diagonal sweep commencing in the foreground. The horizon is high, and there is a low building in the background. The brushwork is energetic, and the tree branches seem scratched onto the surface of both paintings.

Sargent did several informal portraits of his friends and their children. For the most part, these were inspired by whim. A charming passage from Gosse describes one of these portraits:

He was painting, one noon of this radiant August of 1885, in a white-washed farmyard, into which I strolled for his company, wearing no hat under the cloudless blue sky. As I approached him, Sargent looked at me, gave a convulsive plunge in the air with his brush, and said, "Oh! what lovely lilac hair, no one ever saw such beautiful lilac hair!" The blue sky, reflected on my sleek dun locks, which no one had ever thought "beautiful" before, had glazed them with colour, and Sargent, grasping another canvas, painted me as I stood laughing, while he ejaculated at intervals, "Oh, what lovely hair!"[30]

The brushwork and lighting of the portrait studies are handled like the landscapes—broadly and naturally. *Young Girl Wearing a White Muslin Blouse*

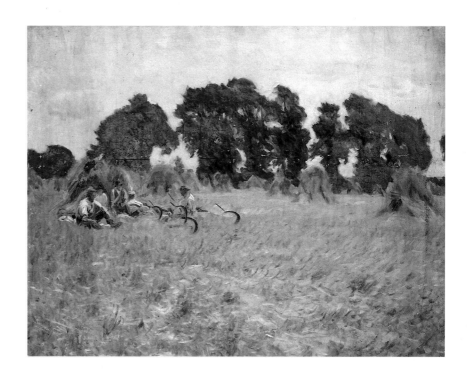

Fig. 20
John Singer Sargent, *Reapers Resting in a Wheat Field,* 1885. Oil on canvas, 28″ × 36″. Metropolitan Museum of Art, New York, gift of Mrs. Francis Ormond.

(Plate XVI) is a rapidly brushed painting of one of the Broadway children. The light streams from the upper left, dappling her face, hair, and dress.

Fall was harvest time, and this event inspired two paintings. *Reapers Resting in a Wheat Field* (Fig. 20) is a fresh and immediate response to an annual pastoral event. The brushwork is delicate and consistent; the figures are economically brushed and are integrated into the landscape. The other painting inspired by the harvest has a different character. *Girl with a Sickle* (Plate XVII) is staged. This is not a day laborer but one of the ladies posing. The rapid and broad brushwork and sketchy quality of the landscape are Impressionist, but the sentimental, near-bucolic mood is more akin to the picture of the Vickers children (Plate IX) of 1884 as well as to the artist's blossoming tour de force—a large twilight study of two girls standing among flowers while lighting Japanese lanterns.

Sargent had to do something about his career, which was declining. In a rare moment of candor, no doubt brought on by discouragement, he confided to Gosse that he was considering giving up art. Sargent knew that his only course was the Salon or its British equivalent, the Royal Academy. The year before, he had exhibited his portrait of Mrs. Henry White there. The reviews were not especially good, but the painting won him a few converts. Another appearance at the Academy was called for, and he had a subject in mind. He had already painted children in a garden surrounded by lilies. The Japanese lanterns that he had seen at Pangbourne would do well. The effects of lamplight in *A Dinner Table at Night* pleased him. The glow of the lanterns could be integrated with twilight, an effect he had enjoyed in *In the Luxembourg Gardens* and in *Capri.* In a sense, the subject was a natural; he would paint it true to Monet's credo—entirely out of doors. And that is just what he did, for twenty minutes a day at twilight over a period of two years.

Standing in front of *Carnation, Lily, Lily, Rose* (Plate XIX), one is struck by its size (68½ × 60½ inches) and bright color. Sargent's dedication to the out-of-doors execution of this monumental canvas paid off. Its incandescent color, painted at a time of day most favored by Monet, seems exaggerated.[31] It isn't, though. The clear blue light of twilight has heightened the effect and inten-

sified the natural hues. The glow of the lanterns warms the faces of the girls as the natural light cools the landscape. The technical brilliance, the fact that it was a tour de force of modernism, was blithely overlooked by the critics of the 1887 Academy. Everyone loved the girls and the flowers. Sargent was a hit— perhaps for the wrong reasons, but nonetheless a hit.

There are two 1885 paintings worth noting here, both interior scenes. *The Candelabrum* (Plate XX) was a rapid sketch of his friend Flora Priestly[32] at the dinner table. She seems to be lost in thought. Her eyes are cast down, contemplating her cigarette, which is concealed although its puff of smoke is visible. The broadly handled, momentary glimpse continues the theme of the dinner table. As a subject, this painting is not unlike the sketch of *Madame Gautreau Drinking a Toast* (Isabella Stewart Gardner Museum, Boston), painted a few years earlier. But that painting's strong chiaroscuro, tight brushwork, and sharply focused light have none of the evenly lit, flickering, Impressionist sensibility of the Priestly sketch. In October 1885, Sargent visited Robert Louis Stevenson at nearby Bournemouth and painted him for the second time. The first version (1884) is lost; the third was executed in 1887 and shows the writer casually seated and smoking a cigarette (Fig. 21). In the second version, *Robert Louis Stevenson and His Wife* (Fig. 22), the frail author, crossing the room, is caught in mid-stride. In the middle of the canvas, an open door reveals a staircase and a hall, which adds a sense of mystery to the space and is reminiscent of the Venetian interiors. To the right is a rapidly brushed sketch of Mrs. Stevenson exotically dressed in Oriental attire, slouched in a chair, and cropped at the knee. The momentary, eccentric nature of the painting shows Sargent's continued interest in the theme of the quickly glanced interior, here illuminated by a pervasive, naturalistic interior light. Both paintings of Stevenson bear a distinct resemblance in handling, brush-work, pose, and spirit to Manet's 1876 *Portrait of Stéphane Mallarmé* (Fig. 23). In this small canvas, the poet is seated, slouched to his right. His hand rests on a manuscript, holding a lit cigar, the smoke rising. Sargent saw this picture at the Beaux-Arts Exhibition of Manet in January 1884, where it was shown publicly

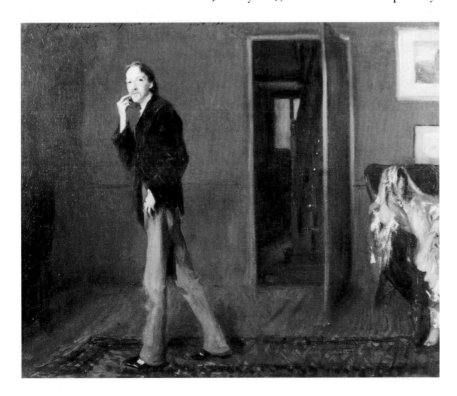

Fig. 22
John Singer Sargent, *Robert Louis Stevenson and His Wife*, 1885. Oil on canvas, 20½" × 24½". Mr. and Mrs. John Hay Whitney, New York.

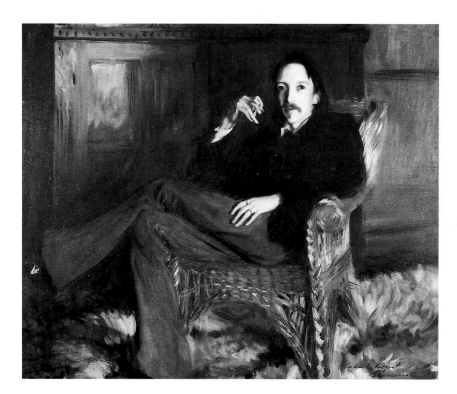

for the first time. Its resemblance to the Stevenson portraits, especially the third, is too close to be coincidental.

Sargent stayed at Broadway until late in the year, returning the following summer to complete *Carnation, Lily, Lily, Rose.* The large canvas had been stored in the barn at Farnham House. This season (1886), Abbey and Millet rented Russell House, a property adjacent to Farnham House. The happy schedule of the previous year was resumed by this harmonious group, closer now than the year before. Since he worked on *Carnation, Lily, Lily, Rose* only for a brief time at twilight, Sargent produced a number of other canvases during this summer and fall. Naturally, a favorite subject was flowers.[33] *The Millet House and Garden* (Plate XXI) is a daring composition depicting a

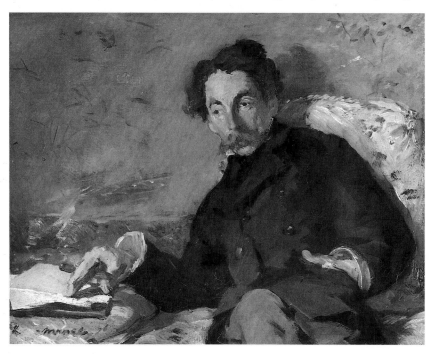

garden path at Russell House. The dark-green cast shadows indicate late afternoon. This seems to be the time of day when much of his painting was done. The potted lilies had been planted by Lucia Millet, who wrote that she "put 20 in pots and forced them for his big picture [*Carnation, Lily, Lily, Rose*] the others to go in the garden anywhere I like."[34]

The Old Chair (Plate XXII) has cast shadows on the lawn much like the above painting. This unusual still life has a random quality to its composition, yet no more so than many of the cropped interiors. The facture is richer and the brushwork somewhat broader than the previous year, again relating to late Manet. When Sargent saw the Manet exhibition at the Beaux-Arts in early 1884, he wrote to a friend: "It was the most interesting thing in Paris."[35] The same technique is seen in another unusual composition of a rose trellis painted this same year. The thick brushwork and cast shadows are also seen in *In the Orchard* (Plate XXVI). The seated figure dressed in black may be the widowed Mrs. Williams, sister of Mrs. Gosse.[36] The long, dark-green shadows again indicate late afternoon. The brushwork is energetic and rich, and there is consistency in the handling of the landscape and the figure. Figure and landscape are integrated in the same way they were in *Reapers Resting in a Wheat Field*.

Despite the high-key palette and vigorous, small brush strokes, values still define form. Mrs. Williams is not dematerialized by the light; we still sense her solidity and her concentration as she sits sketching in the orchard. Likewise, *The Old Chair* has weight, volume, even character (cf. the same subject by Van Gogh, *Vincent's Chair*, Tate Gallery, London, on loan from the National Gallery). The path in *Millet House and Garden* recedes realistically in perspective. Sargent has taken some of the tools of the Impressionists and has utilized

Russell House, Broadway, 1985.
Photo courtesy of Jan P. Adelson.

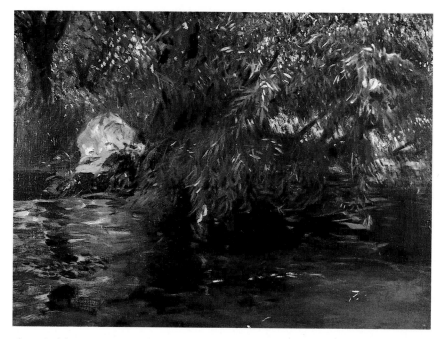

them in his own way. He has clung to form and drawing as Renoir returned to it. To take the next step—to allow light to dematerialize form—he needed more than inclination. He needed incentive. Perhaps that was just what was provided by the sensational reception of *Carnation, Lily, Lily, Rose* at the Royal Academy in March 1887. Not only did the critics like it, the public raved about it, applauded him for it, and, more importantly, the Chantrey Bequest bought it.

While *Carnation, Lily, Lily, Rose* was being exhibited at the Royal Academy in 1887, Sargent also participated in the exhibition held by the New English Art Club, of which he had been a founding member the previous year. He felt that this organization, which was united in its "hostility to the Royal Academy and enthusiasm for modern French naturalistic painting,"[37] was the perfect showcase for his Impressionist works. Sargent contributed his most experimental work here, placing himself "firmly in the van of the avant-garde movement, and the *Art Journal* could refer to him, with some justice, as the 'arch-apostle' of the 'dab and spot' school."[38]

At the time of Sargent's visit to Giverny that summer of 1887, he saw Monet, who had long been fascinated by painting water, working in his studio-boat, painting his stepdaughters in punts, attempting to capture the undulation of the water's surface as it reflected what was above it and revealed what was below it. Monet was trying to weave the fabric of figure and landscape into one. "It's an old dream that always troubles me, and I want to realize it once and for all."[39] This small group of paintings represents a subchapter in a constantly evolving *oeuvre*, but it had taken on great significance to Monet, always a perfectionist.

Later that summer Sargent visited Robert and Helen Harrison. He had met them through the painter Peter Harrison, whose future wife was Alma Strettel, a lifelong friend of Sargent's.[40] The Harrisons invited Sargent to their home, Shiplake Court at Henley-on-Thames, to attend the Henley Regatta, the social boating event held annually in late June or early July (varying each season). It was here that Sargent proceeded to paint several fascinating and revealing pictures.

While at Shiplake Court, Sargent boarded his own studio-boat. The adventure is colorfully described in the autobiography of Sir George Henschel,

composer, singer, and conductor, who met Sargent at Henley that summer and became a fast friend and an admirer (Sargent painted his portrait in 1889). Sir George wrote: "[Sargent] had built himself a little floating studio on a punt on the river, where it was a delight to see him, a splendid specimen of manly physique, clad it was an exceptionally hot and dry summer, I remember in a white flannel shirt and trousers, with a silk scarf round his waist, and a small hat with colored ribbon on his large [sic] head, sketching away all day, and once in a while skillfully manipulating the punt to some other coign of vantage."

Under the Willows (Plate XXVII) was painted from Sargent's studio-boat, as is evident from the point of view. The artist later confirmed that the lady in the punt was Helen Harrison and that the work was executed from his studio-boat at Shiplake Court during the 1887 Henley Regatta. For some years it has been mistitled *Calcot Mill*. The brush strokes are distinct, smaller than before, and form an overall pattern on the surface of the canvas. The water reflects the deep-green trees, the light penetrating the densely foliated shore, and the punt itself. The lady in blue seems asleep in the dreamlike setting. The boat is adrift, floating in the light and in the dense atmosphere.

A similar subject is depicted in the Baltimore Museum picture, wrongly entitled *A Backwater, Calcot Mill near Reading* (Fig. 24). This work was not executed in Reading in 1888 but belongs to the group of works done in 1887 at Henley. It is painted aboard the studio-boat, this time only suggesting the drifting punt with parasol behind the overhanging tree. The brushwork is small, tight, and delicately applied, without the bravura sweep and staccato stroke of 1886. Gone is the sense of solidity created by values and line. Color and brushwork create the space, form, perspective, and pictorial effect. In *A Backwater at Wargrave* (Plate XXVIII), the artist has done away with the figure and punt, concentrating on the overhanging trees, the opposite riverbank, and the reflected light in the water. The painting is unified by the brushwork and light effects, not by composition, values, or traditional perspective.

In another painting of this period, the artist got closer to the figures. In *A Lady and a Little Boy Asleep in a Punt under the Willows* (Fig. 25)—probably

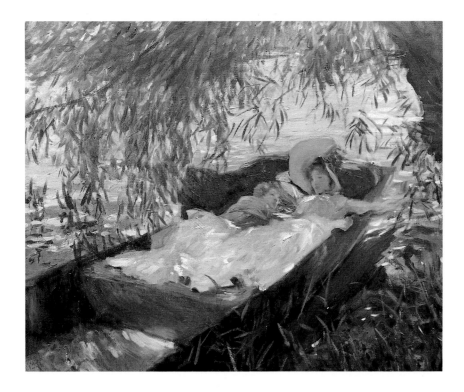

Fig. 25
John Singer Sargent, *A Lady and a Little Boy Asleep in a Punt under the Willows*, 1887. Oil on canvas, 22″ × 27″. Calouste Gulbenkian Foundation Museum, Lisbon, Portugal.

Helen Harrison with her son Cecil—the artist was alongside their punt watching bright sunlight filter through the trees to create a dappled effect on the two dozing figures. Remembering Henschel's comment on the heat of that summer, it isn't surprising to find people napping during the heat of the day. Again, the brushwork is formed in short, narrow strokes delicately touched across the surface. The punt sits upon the water in the same ghostly fashion as Monet's *La Barque à Giverny* (Fig. 5) or the figureless rendition of the same subject, *La Barque* (Fig. 26). This ghostlike effect is also achieved in *Gust of Wind* (Plate III), which Sargent painted while visiting his friend Judith Gautier in St. Enogat. She was the daughter of poet Théophile Gautier and was for many years the mistress of Richard Wagner, whose music was one of Sargent's few addictions. Here she is caught atop the dune that led to the beach on her property. The wind catches her off guard as she grabs her broad-brimmed hat, which performs the same function as the parasol in Monet's *Essai de figure en plein air* (Fig. 4). The bright sun dematerializes the figure and flattens it against the sky. It is as though she is Madame Monet standing up; she is as flat and dematerialized as that lady in *Claude Monet Painting at the Edge of a Wood* (Plate II). Commencing in 1883, Sargent painted several informal studies of Judith Gautier in oil and watercolor. *Gust of Wind* is the most evanescent of all the paintings of her and is the last of the series.

Before going to America, Sargent painted another interior scene, a subject that recurs throughout his career. Figures gathered around a table illuminated by artificial light was a subject briefly explored by Monet in the late 1860s; *The Evening Meal* (Zurich), exhibited in 1880 in Paris, is a fine example of an Impressionist interpretation of interior light. Sargent's *Fête familiale* (Fig.

27) celebrates the birthday of the son of his friend, painter Albert Besnard, and was painted for the boy's sixth year. Sargent has become bolder and more painterly than before. The handling of the objects on the table, the lush crimson color, the breadth of brushwork, and the light bursting from the lamp attest to the artist's sense of freedom and his self-confidence in portraying this intimate occasion. *The Breakfast Table* (Fig. 18) of three years earlier (1884) seems tight and restrained in comparison to the spontaneity and freedom of this canvas.

With renewed confidence exemplified by this deftness of stroke and surety of handling, Sargent accepted Henry Marquand's offer to paint his wife in Newport, Rhode Island. It was a commission filled with promise. He wrote Monet, "I have some orders for portraits over there, and a very pleasant opportunity of staying there for two months. I am going on September 17th."[41] In the same letter he mentioned *Vagues à la Manneporte* (also known as *Rock at Tréport*) (Fig. 28) by Monet, which he had just acquired, saying, "I can hardly tear myself away from your exquisite painting for which, you say, 'you do not share my admiration' (come now), in order to tell you once again how much I admire it. I could spend hours looking at it in a state of stunned delight, or rapture, if that is a better word. I am thrilled to have such a source of joy in my house." Sargent then went on to comment on his own work done in the studio-boat that summer: "Although I have worked a lot on the Thames lately I have nothing to show for it. This is partly because the prospect of this confounded journey prevented me from completing the painting; and partly too the material difficulties of painting people in boats, on the water, between boats, etc." He would have better luck at it after the trip to America.

From the moment he arrived in New York, he felt that he had come home. His reputation in the States far exceeded his standing in England or France. His name had been associated with triumphs and scandal at the Salon in Paris and the Royal Academy in London. He had exhibited in America since 1878. By today's standards, he would be an international star to East Coast ladies and gentlemen longing for the chic of Europe. His friends Abbey and Millet had certainly "talked him up" to their American contacts, and Henry James had

Fig. 27
John Singer Sargent, *Fête familiale (The Birthday Party)*, 1887. Oil on canvas, 24″ × 29″. Minneapolis Institute of Arts, Minnesota, the Ethel Morrison and John R. Van Derlip Funds.

Fig. 28
Claude Monet, *Vagues à la Manneporte,*
c. 1885. Oil on canvas, 28¾″ × 36¼″.
Private collection.

written an illustrated essay about him in the October issue of *Harper's New Monthly* to coincide with the artist's arrival. Influential friends introduced him to others. He was overwhelmed with commissions. He painted the illustrious Mrs. Jack Gardner. The exhibition at the St. Botolph Club in Boston opened in January 1888 and included twenty paintings, among them formal portraits, Venetian scenes, and the sensational (over 11 feet long) *El Jaleo*, which was owned by a Bostonian, Jefferson Coolidge. The critic of the *Boston Evening Transcript* said:

> No American has ever displayed a collection of paintings in Boston having so much of the quality which is summed up in the word "style". There is an indefinable but palpable atmosphere of refinement, ease, and *tranchons le mot*, aristocracy.[42]

Society courted him because he was famous, liked him for his modesty, and responded to his paintings with a native instinct. As Ormond points out, Sargent's portraits had a directness, an honesty, a sense of real personality that had not been seen since Copley. Moreover, in America the portraits of these often uncompromising folk took on just that character stylistically. These paintings generally are more direct, more realistic than Sargent's European portraits. Americans loved what Sargent did, and he did it more and better for them.

"Sargent must have made every effort to acquaint his compatriots with the work of Monet. . . . It may have been partly due to Sargent's proselytizing that, in 1888, Williams and Everett, the oldest gallery in Boston, decided to purchase from Durand-Ruel Monet's *Chemin de la Cavée, Purville* (W.762), the earliest documented painting by the artist to have appeared in that city. An acquaintance of Sargent's, Peter Chardon Brooks, whose portrait Sargent would soon paint, might have been the first Bostonian actually to own a work by Monet, a snow scene at Argenteuil which apparently was purchased in 1888."[43] Sargent's promotion of Monet continued into the twentieth century. Commencing in 1900, Monet met with Sargent often in London while the Frenchman was producing his extended series of London views. "Sargent prepares his trips for him and arranges interviews with collectors who are likely

to show Monet paintings, which he is dying to see. In the evening, Monet often joins him in Chelsea, where he may find him playing the piano or writing letters."[44]

On May 19, 1888, Sargent set sail for England, his permanent residence since 1886. He was accompanied by the quixotic, immensely talented American painter Dennis Bunker, a mutual friend of Mrs. Gardner. But for a dark cloud, this had been the most splendid year of Sargent's life. Sadly, his father Fitzwilliam had suffered a stroke in Florence in January and had been convalescing in a state of uncertain health. After some indecision, Sargent rented the house at Calcot Mill, Oxfordshire, not far from Pangbourne. Here the family was brought together in June, it now being apparent that Fitzwilliam was dying. It was a much reduced Broadway. Bunker was there; Vernon Lee and Flora Priestly were present. Sargent's sister Violet, now nineteen, was with the family, and it seemed that a romance might be brewing between her and Bunker (at least that was Bunker's view of it in a letter to Mrs. Gardner). Nothing came of it, however. Due to Fitzwilliam's illness, all was subdued.

The house at Calcot Mill is medium-sized and of graceful proportions. A finger tributary of the Thames flows by, turning the mill and creating an especially lush and verdant setting. Willows overhang the small pond created by the river in front of the house, where ducks are found to this day. Adjoining the mill are flat, open fields bordered by trees. It is no coincidence that the river Epte at Giverny bears a distinct resemblance to the estuary at Calcot. Both bodies of water are of equal width, ranging from 5 to 8 feet, and are 1 to 3 feet deep. Each is overhung by willows with shallow banks and bordered by broad fields with distant hills. The ponds formed in front of the houses are similarly oval-shaped and have almost identical dimensions. They are still, quiet pools, idle in mood, with a barely perceptible movement. Here, in the summer of 1888, mindful of his dying father, Sargent, with Bunker in tow, painted several very special pictures.

Calcot Mill, Oxfordshire. Private collection.

Left:
The river at Calcot Mill, 1985.
Photo courtesy of Jan P. Adelson.

Right:
The river Epte at Giverny, 1985.
Photo courtesy of Jan P. Adelson.

Fig. 29
John Singer Sargent, *A Morning Walk,*
1888. Oil on canvas, 26⅜″ × 19¾″.
Ormond Family.

During the previous summer of 1887, Sargent's routine had been determined by his impending American voyage. At Calcot in 1888, the scenario was different. With the success of *Carnation, Lily, Lily, Rose* in the spring of 1887 and the financial triumph of his eight months in America, Sargent's self-confidence must have been high in that summer of 1888. He was yet to fall into the trap of overburdening portrait commissions, and he had passed from being promising to being successful. This summer he was free to paint. The experience with the studio-boat last summer had been of great value. He would paint Impressionist pictures. Calcot was ideal. The terrain was glorious, and there were live-in models. The inhabitants of the house spent the days walking, lounging, and punting on the pond. It was Giverny in England.

A Morning Walk (Fig. 29) is an Impressionist painting. Violet Sargent is walking by the river in the full light of day. The hot sun intensifies the bright-green lawn, and the blue sky is reflected in the unusually dark river—it is shallow with a brackish bottom. Violet's dress is alive with blue and violet shadows, heightened by creamy white accents reflecting the noon light. The inside of her parasol is a harmony of blues, greens, yellows, and whites. Monet's *Essai de figure en plein air* (Fig. 4) inspired this painting. In Monet's canvas, dated 1886, Suzanne Hoschedé is seen from below, the figure against the sky. Sargent has tilted the point of view to look down on the figure, set against the water, which reflects the sky. Sargent had tried the same subject the previous year in *Gust of Wind* (Plate III), in which he, like Monet, looked up at the figure. That picture is more summarily handled than *A Morning Walk,* but in both we are close to the figure and have a sense of their identity. Their features are recognizable, Judith's round face and dark eyes, Violet's delicate nose and chiseled red lips. In the Monet, Suzanne is more ghostlike on the hill, her features just barely articulated. In both the Monet and the Sargent, there is a homogeneous surface. All elements—figure, sky, water, flora—are treated alike. They are all reflectors of light and foils for its effects.

The Metropolitan Museum's *Two Girls with Parasols* (Plate XXIX) shows Violet in the foreground followed by another woman, probably Flora Priestly. Neither has features, although Violet's delicate profile identifies her. They are painted in the same narrow, long strokes that we saw in 1887, the surface of the canvas covered in this way disintegrating the form of figure and landscape into an impression of light and color. Sargent painted the same two women seated under two trees in the watercolor *Under the Willows* (Plate XXX). They are again featureless, defined by light and color, not value. This same delicate, staccato brushwork is seen in *Saint Martin's Summer* (Plate XXXI), painted at the end of his stay at Calcot. Saint Martin's Day is November 11; the title is synonymous with Indian summer. Both ladies recline, dozing in a punt, the artist working from the dock next to them. The mood is serene; summer is over. The surface sparkles with rich color and light. There is very little sky visible, as is true of all Sargent's paintings of this period. The riverbank and trees serve as the background, the light disintegrating them, the sky reflecting in the water, the sun dematerializing the figures and punt before us. The careful brushwork is especially like that of *A Backwater at Wargrave* (Plate XXVIII), painted the year before on his Henley excursion. This year in July, Sargent returned for a week to the regatta, staying with his friend Alfred Parsons at Red House, Shiplake.[45] He may have tried the studio-boat again, but it is not recorded nor is it likely. Remembering the letter to Monet, he wasn't entirely satisfied with it.

Femme en barque, 1888 (Fig. 30), depicts a lady reading in a punt, perhaps Flora Priestly (the prominent nose and long face suggest her).[46] The artist is

positioned opposite her in the boat. The brushwork is the same tapered and delicate stroke of the 1887–1888 period; the background is dense, closed, and the water of the pond reflects the trees and sky. Ducks are seen in the distance; they abounded at Calcot Mill. *By the River (Violet Sargent and Dennis Bunker)* (Plate XXXII) was painted from the shore, the artist looking down at the figure in the canoe—Bunker—with Violet kneeling on shore holding the craft with her right hand. Her left hand touches the handle of the parasol behind her. The man is featureless. Violet's fine features are lightly indicated, and two other figures on the right are rapidly brushed and appear to be as much floating as walking toward us. The light is suffused in the shade of the tree. The poses of the figures are convoluted. Sargent would repeat this effect the following year in Fladbury. In 1888, he did another splendid painting of this couple.

As a subject, *Dennis Miller Bunker Painting at Calcot* (Plate XXXIII) is identical to the *Monet Painting* (Plate II) of 1887, with subtle differences. Bunker is dressed in white with a red waist sash (an outfit not unlike that of Sargent's as described by Henschel, above). With his right hand in his pocket and his left hand holding the palette down beside him, the handsome young painter studies his work, which is propped up on a makeshift easel, the back of the canvas toward the viewer. He is recognizable; his features are articulated. Sargent had painted a portrait head of him earlier in the year (Tavern Club, Boston). Bunker studies his own work, which we can't see. In *Monet Painting*, the French artist is working on a canvas which we do see. He is seen in profile, and but for the hat and beard he is barely recognizable. He is less Monet the man than he is the painter in his milieu, intently at work on a landscape *en plein air*, his high-keyed, loaded palette flashing in the sun. It is more a tribute to painting out of doors. Bunker is seen less as the artist in pursuit of his craft than as a personality evaluating his work. It is a fine point but, in view of Sargent's reverence for Monet as a painter, one worth noting. Violet sits by the stream, her back to Bunker, holding a parasol in her left hand and a book that she is reading in her right. Like Mme. Monet in *Monet Painting*, Violet is rapidly indicated and wraithlike. Both women float. The figure of Bunker is more substantial but still integrated with the landscape. Trees serve as a backdrop, and there is some sky to our left and more flickering through the trees to the

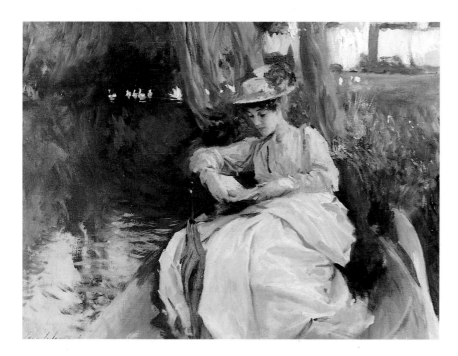

Fig. 30
John Singer Sargent, *Femme en barque*, 1888. Oil on canvas, 20″ × 27″. Private collection.

51

right. The brushwork is small and carefully applied, with strokes of yellow, orange, and green interspersed on the lawn and in the trees. A sense of perspective is achieved by color and brushwork, as is the sense of form. The darks are more local hues than values, which barely come into play but for the articulation of the heads. The overall effect is the play of light across the surface of the canvas.

That winter Sargent moved back to London and settled his family at Bournemouth. His father died peacefully there on April 29, 1889. It was a sorrowful time for Sargent. In London, portrait commissions were few. Despite the acclaim for *Carnation, Lily, Lily, Rose*, he had gained a reputation for being too acute in his portrayal of personality. The British disliked that quality in Sargent's work that had so appealed to the Americans.

Sargent's time in London was unfortunately his own. In February he painted the complimentary portrait of George Henschel while the talented musician stood on a platform and sang. Sargent was impressed by Ellen Terry's Lady Macbeth and persuaded the actress to sit for him. He was thrilled by the prospect of painting her. In a letter to Mrs. Gardner he exclaimed: "From a pictorial point of view there can be no doubt about it—magenta hair!"[47] He showed her in costume—a magnificent peacock dress—her hands holding a crown above her head, a pose reminiscent of the portrait of Mrs. Gardner but with arms raised. It was exhibited that spring at the New Gallery in London and was criticized for being too realistic. It was not Lady Macbeth, seething with the passion and malevolence of that role, but a portrayal of the actress, "stage paint on her face, lips contorted to move the pit, eyes shining in the footlights glare."[48] The brilliantly hued, dazzling dress was painted in distinct, narrow, carefully rendered strokes, taken directly from the Calcot work. It was Sargent's Impressionist brushwork applied to a realistic portrait—a synthesis of techniques.

In May, Sargent exhibited *Saint Martin's Summer* and *A Morning Walk* at the New English Art Club. These were his two most daring works, his interpretation of Monet's Impressionism. The reviewer of the exhibition said that the two paintings were "evidently painted under the direct inspiration of Claude Monet, but they are none the worse for that. We must confess to finding them somewhat unpleasing in colour, but we acknowledge their veracity and their infinite cleverness, and they scintillate with sunlight."[49] This was, no doubt, the prevailing opinion at best. It was hardly encouraging.

Sargent went to Paris in June and met with Monet. During the past months, he had actively worked with the French artist to raise funds for the purchase of Manet's *Olympia* for France. "He [Sargent] had arranged for its sale to an American collector when he was persuaded by Monet to alter its destination."[50] They raised Fr 20,000 for Manet's widow, who expressed her gratitude to Sargent in a letter to Monet. Sargent contributed Fr 1,000. The two artists met at the Exposition Universelle, where they were exhibiting. Here they could see *Olympia* on view along with a section devoted to works by Manet. Later, Monet invited him to visit Giverny that summer. Sargent had to decline because he was detained "by the Javanese,"[51] a troupe of dancers from the South Sea island who were performing at the Exposition in a reconstructed Java village.

At the Exposition, Sargent had six portraits in the American section and was awarded the Legion of Honor by the French government. Among the sights to be seen at this fair were the troupe of Javanese dancers. They enchanted him. He had always been drawn to the exotic, and these colorfully clad, graceful, lithe creatures appealed to him instantly. He did many studies

John Singer Sargent, *A Javanese Dancing Girl*, 1889. Oil on canvas, 68½″ × 30″. Ormond Family.

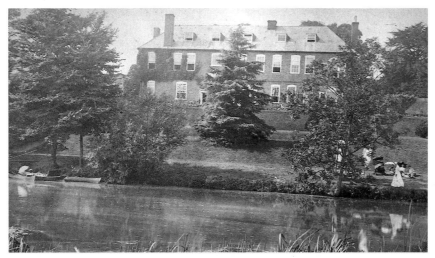

The rectory house at Fladbury, c. 1889.
Photo courtesy of Ormond Family.

and three large, vertical canvases of the dancers. He captured their stylish, Oriental movement in thin washes of oil applied in a broad, loose fashion. There is a sweeping quality to the turpentine washes, unlike the controlled brushwork, facture, and rich surface of *Ellen Terry* and the Calcot paintings. Sargent was more interested in the movement—or, rather, the frozen movement—of these performers. It was their mannered twisting, their positions, that appealed to him—the antithesis of the naturally gathered figures standing and lounging around the river by the mill. These Javanese were all pose, all theater. They form a logical bridge to his summer's work in Fladbury.

Prior to his father's death, Sargent had leased the rectory house adjacent to St. John the Baptist's Church at Fladbury. The location was convenient—it was only seven miles from Broadway. The house was large and hovered over three terraced lawns descending to the Avon. The river is a good deal wider and deeper than that at Calcot, and beyond the opposite banks were broad, open fields. There was a small dock and a mill on the far bank to the south. The spacious house was empty, and guests were frequently invited. Among those in attendance that summer were Flora Priestly, Alfred Parsons, Vernon Lee and her friend Kit Anstruther-Thomson, Paul Helleu and his young bride Alice, Edwin Abbey in September, and others. Sargent, shaken by his father's death, was surrounded by friends. It was another river setting with live-in models.

This season, instead of Bunker, Paul Helleu was there to join Sargent in the field. Sargent resumed some of the themes developed at Calcot, but his style had changed. *In a Punt (Violet Sargent and Madame Paul Helleu)* (Plate XXXIV) is a small, rapidly brushed canvas with a familiar theme. There are some significant differences, however, between this canvas and those of the previous two years. In the Fladbury painting, the figures are entwined in a complicated pose. Violet, the farther figure, leans away, her right shoulder toward the river, her head in profile. Alice Helleu's back is to us, her left shoulder dropped, revealing the left side of her face and the underside of her hat. The women are in bright sunlight, which glares off the river in a column of light to the left. Violet's head is framed by the dark water on the right. The brushwork is thick, the strokes long and attenuated, not the separate, narrow, fine strokes of the year before. Nor is this convoluted arrangement of figures like Calcot.

In another canvas, the same two ladies are seen on the grass (Plate XXXV). Violet, in dark dress and light hat, is sleeping, her hands under her face, while Alice, in white dress and dark hat, props her head on her right arm, her eyes closed. It is a lazy day in the hot, bright sun. The brushwork is broad and thick.

The river Avon at Fladbury, 1985.
Photo courtesy of Jan P. Adelson.

The green grass serves as the background and is blocked in by broad turpentine washes similar to the broad red washes behind the turning, convoluted performer in *A Javanese Dancer*. There is a small watercolor of Violet reclining (Plate XXXVI), eyes closed, hands under face, hat tipped. The lines are angular and the color applied in broad strokes. Sunlight heightens the bright blue-striped dress and pale white skin of the twenty-year-old woman. The effect of the awkward pose and bright color is startling.

Violet Fishing (Plate XXXVII) is a variation of Monet's theme, combining the motifs of the figure against the sky and the woman fishing. This smaller canvas is a preliminary version of the full-sized, unfinished work in the Tate. Violet stands before us, turned to the river, head in profile. The pose is similar to *A Morning Walk*: both figures are close to us, grass at their feet, water behind them, the riverbank in the distance. In the Calcot picture, she holds a parasol which serves as the backdrop for her head. In the Fladbury picture, she holds a fishing pole, her head backlit by the river's glare. The effects of light in *A Morning Walk* are dappled—the surface sparkles and reverberates with dancing light. These effects are different in *Violet Fishing*. The sun functions as a spotlight, creating a column of light that glares in a great beam. Violet is brightly lit but substantial at the same time. The distant riverbank, with its dark shadows and darkly reflected trees, creates a distinct sense of three-dimensional space. We know the river is wide; it is defined by the angular composition and the aerial perspective of the far shore. That shore is not a backdrop, as it was in 1887 and 1888. It is a place with a definite distance from us.

Late in the season Sargent painted Violet reclining in a punt with the river behind her. *Autumn on the River* (Plate XXXVIII) shows her dressed in dark fall clothes, a charcoal-gray dress and a fur cape at her shoulders. Sargent was in the boat, a position he had taken before (*Femme en barque* and others). The foreshortened figure is twisted as her right hand holds the side of the boat. The pose seems purposefully contrived, mannered in the same way the Javanese dancers and Violet and Flora are. Here, Violet lacks the natural ease of *Saint Martin's Summer* or *A Lady and a Little Boy Asleep in a Punt under the Willows*. We sense her body beneath the drapery. The drawing is sure. The light is not bright due to the time of year, but it still floods the river and strikes the face of the woman with theatrical effect. The overhanging branches to the right reflect autumnal colors, creating a sense of depth in the river and echoing the hue of the boat's interior and the sitter's dress. The same burnt-sienna tone is seen at the distant riverbank; the pale blue of the sky is repeated in the river. The river, the distant shore, the farther hills and sky are a study in aerial perspective. The progression of space is masterful; we sense the great length of the river and the very far distance of the hills beyond. This treatment of space is in direct opposition to the spirit of the paintings of the previous two years. The brushwork is broad and sweeping; gone are the detached strokes. Color and light do not disintegrate form but define it.

Paul Helleu Sketching with His Wife (Plate XXXIX) is the artist's third rendition of this subject in as many years. The differences between this painting and the two others (*Monet Painting at the Edge of a Wood* and *Dennis Miller Bunker Painting at Calcot*) are revealing. In the Helleu picture, we are closer to the figures. This is not accidental. It is a portrait of Helleu and the beautiful and bored Alice. By looking at her face, we know she is bored. We know it is Paul Helleu by the angular cheekbones, thin nose, and long, narrow beard. His right hand gestures gracefully as brush touches canvas. His left hand gently holds the palette and six other brushes. The canvas is propped facing Helleu; we see only its rear edges. This is not the near-anonymous

Monet with his faceless, wraithlike wife. Nor is it the quickly articulated figure of Bunker, seen at a distance, integrated into the landscape, accompanied by a faceless, summarily indicated Violet. (We know it is Violet only because we are told so—there is no way to recognize her.)

The Helleus are two specific people. They are firmly modeled. The composition is classically structured: the red canoe forms the left side of the triangle created by the canvas edge at the bottom and the line of Helleu's left arm and leg at the right. Counterthrusts are provided by the pole supporting the canvas and the horizontal figure of Alice Helleu. This group is light in color but tightly rendered. The surrounding grass is handled in the narrow, controlled, Impressionist manner of Calcot: it is painted with *brio*; light shimmers and reflects in it. This picture was posed outdoors but finished in the studio. There are numerous drawings of Alice Helleu that are studies for this picture. This is not true of the Monet or Bunker picture; they were executed *au premier coup* on location. Moreover, there is a photograph of the Helleus in this pose.[52] No doubt it was used as an *aide-mémoire* for Sargent in the studio. It is worth noting that Sargent was pleased with this picture. It was exhibited in 1892 at the New English Art Club along with two works by Monet, who had been invited by Sargent to contribute (Monet's address was listed as c/o J. S. Sargent).[53]

Paul Helleu Sketching with His Wife is a brilliant and compelling picture, but it is a considerable step away from the plein-air, integrated surface of Monet and Sargent's own attempts at this technique in 1887 and 1888. It relates in technique more to the later works of Manet, whom Sargent greatly admired. The areas of flat local color and the precise draftsmanship of the figures seem to be Sargent's method of integrating realism and Impressionism. At the Manet retrospective in 1884, Sargent had seen works like *The Bar at the Folies Bergères* (1881) and *In the Conservatory* (1879), and in June 1889, at the Exposition Universelle, he had just seen *Boating* and *My Garden*, among others. He

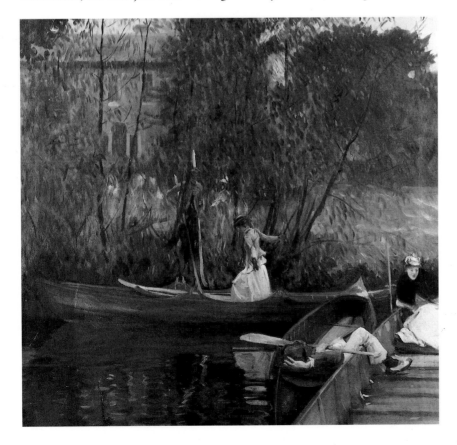

Fig. 31
John Singer Sargent, *A Boating Party*, 1889. Oil on canvas, 34⅝″ × 36⅜″. Museum of Art, Rhode Island School of Design, Providence; gift of Mrs. Houghton P. Metcalf in memory of her husband, Houghton P. Metcalf.

observed the combination of tightly rendered figures, the simplified modeling placed in a setting that was like a modern tapestry or an Impressionistically handled screen. These paintings by Manet had a specific mood. The people in them were individualized.

In his enthusiasm for the artist, Sargent had purchased the study for *The Balcony* at the Manet studio sale in February 1884.[54] Renoir, too, had returned to a more linear approach in 1883. He said, "I had gone to the end of Impressionism. . . . While painting directly from nature, the artist reaches the point where he looks only for the effects of light, where he no longer composes, where he quickly descends into monotony."[55] Sargent saw Renoir's solidly constructed figures placed in an Impressionist setting in such works as *Dance at Bougival* (1883) and others.

The damning criticism of Roger Fry in 1926 is telling. He accused Sargent of "a superficiality of observation which caused him to use Manet's straightforward and concise technique without understanding its aesthetic significance." On the contrary, Sargent knew precisely what he was doing. Technique was always a means to an end for him, and aesthetic significance was never in question. His aesthetic goals had been the same since he was fourteen years old: to paint what was before him as best he could. Technique, once established at the studio of Carolus-Duran, evolved as the years went by, amended and synthesized by exposure and experience but never straying far from roots—realism.

Sargent painted another elaborate composition in this manner. In *A Boating Party* (Fig. 31), Paul Helleu reclines precariously in the canoe, his right foot hooked onto the side of the adjacent punt to keep the canoe in place. Violet is in the punt, seated awkwardly at the bow in a pose similar to that in *Autumn on the River*. She wears the same fur cape and green hat that she had worn in that picture. Her face is illuminated in the same theatrical fashion. Alice Helleu is carefully stepping into another punt, steadying herself on a branch. To her right on the shore is a fourth figure coming toward her through the trees. The artist's point of view is the far end of Violet's boat. The three main figures are tightly rendered, their poses seeming to be an academic exercise in "curious" positions of the body. The fourth figure is sketchily indicated in the trees, perhaps unfinished. The lawn and trees and reflecting water are painted in narrow, carefully placed Impressionist strokes, the water reminiscent of the 1887 studies from the studio-boat. The house is more carefully painted, causing spatial ambiguity: its focus is more precise than the trees, which brings it too far forward. Its red hue makes for the same red/green contrasts that enliven *Paul Helleu Sketching with His Wife*. Like that canvas, it seems apparent that this one was also aided by the use of photography. Due to the complexity of the composition, it appears unlikely that Sargent could have composed the painting any other way. That would account for the off-balance, "empty" feeling created by the water in the foreground as well as the accuracy of the rendering of the building, which gives the impression of being more camera vision than optical. Likewise, the lighting on Violet's face is too similar to that in *Autumn on the River* to be coincidental. It is not the kind of repetition Sargent would use unless it was through the use of the camera. It is meaningful to note that this painting was considered unfinished by the artist. It was stored in his studio for years, never exhibited, and sold by his executors after his death.

Sargent painted many informal portraits, both indoors and out, in the summer and fall of 1889. The *Portrait of Dorothy Barnard* (Plate XLI) is a brilliant example, as much a figure piece as a portrait. The child leaning back against a doorpost seems to be in a pose "caught" by the artist, giving him an

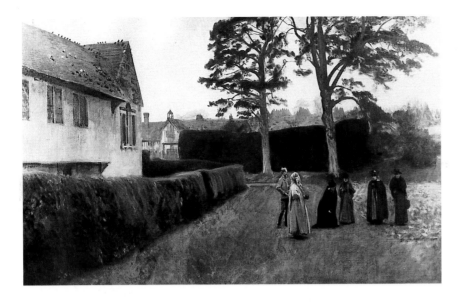

Fig. 32
John Singer Sargent, *Igtham Mote, Kent,*
1889. Oil on canvas, 90¼″ × 56¼″.
Whitney Museum of American Art,
New York.

opportunity to paint her head in profile against a dark doorway. Her pretty
dress is rapidly brushed in an Impressionist manner. Her young face is brightly
illuminated in a fashion like some of the interior lamplit portraits also done at
Fladbury. It is another form of the light as a spotlight.

Sargent painted several interior scenes of the friends assembled at Flad-
bury. *Violet Sargent and Flora Priestly* (Plate XLIII), is another complex figure
arrangement. There is a sense of spontaneity in the playful gestures of both
women—Flora grasping her cape (it must be near autumn), Violet gently
touching the older woman's shoulder. The intimacy is genuine, as is the effect
of light streaming from the window to our left. The scene is enlivened by the
vigorous, narrow brushwork, but form is solid, the foreshortening of both
figures accurate and convincing. In the same period he painted a profile of
Violet at dinner with some pitchers behind her (Plate XLII). The profile head
is seen in full artificial light, the lamp creating a glowing effect on the young
lady's skin and sparkling on the glassware. The brushwork is broad and
smooth, the paint applied almost like cream.

In the fall, Sargent went to Kent to paint young Elsie Palmer, daughter of
the American general. The house was Igtham Mote, and many of Sargent's
friends were guests there, including Comyns Carr and his wife, the Harrisons,
and others. Carr was director of the avant-garde New Gallery and had insti-
gated the commission.[56] Sargent stayed for several weeks, painting many
garden studies and informal portraits, including *Alma Strettel by Lamplight*
(Plate XLIV). She was an old friend of Sargent's and was soon to be Mrs.
L. A. Harrison. The bold frontal light and broad brushwork are similar to that
of the lamplit portrait of Violet just discussed. Sargent also painted a large
outdoor scene, *Igtham Mote, Kent* (Fig. 32), with academically rendered figures
in a tonal, muted landscape, no doubt influenced by the gray and wintry
weather. He returned to Fladbury.

Sargent and his sister Violet went to New York in December 1889. There
he met with Stanford White and White's partners, Charles Follen McKim and
William Rutherford Mead. Plans went forward for the mural decoration of the
Boston Public Library, which "the trustees had resolved . . . should be deco-
rated internally in a manner worthy of the architecture."[57] Sargent's friend
Abbey was there, and he, too, would be one of the muralists. An agreement was
reached with the trustees, and Sargent was to embark on a project that
absorbed his time, interest, and energy for the next twenty-five years.

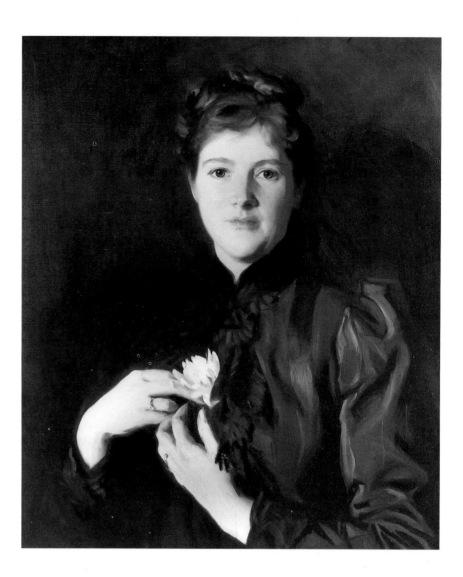

Sargent received commissions in America, and they evidenced his Impressionist technique. The bust-length portrait of Mrs. Augustus Hemenway (Fig. 33) of Boston well demonstrates his new breadth of brushwork, creamier tones, and expressive paint surfaces. The rich impasto and sense of immediacy characterize much of his work from this time forward. Sargent painted another theatrical piece while in New York—that of the dancer Carmencita (Musée d'Art Moderne, Paris), undoubtedly inspired by Manet's *Lola de Valence*, which he had seen in June at the Exposition Universelle. Carmencita is caught in a moment just after turning, gazing proudly at us. It is like the suspended movement of the Javanese or the theatricality of Ellen Terry. The figure is brightly lit, her dress a swirl of bravura brushwork, the hands rapidly indicated.

In June, Sargent executed several portraits in Worcester, Massachusetts, including that of Katherine Pratt seen among an Impressionist mass of hydrangeas. He painted some landscapes there with the same rapid brushwork. The watercolor *Near June Street* (Mead Art Museum, Amherst, Massachusetts) depicts a field seen from below, looking up to the trees and sky. The brushwork is very broad, done in sweeping, casual strokes. *Garden Sketch* (Weatherspoon Art Gallery, Greensboro, North Carolina), an oil, shows a few pots of flowers on the grass, a subject reminiscent of Broadway but handled in a far broader, flashier style. Clearly, landscape was not on his mind. How could it be? There were murals to paint.

In the autumn of 1890, he and Violet returned to Europe—not to England, but directly to Marseilles—joining their mother and their sister Emily and proceeding to Egypt. His intention was to absorb the lore and sensibility of the ancient world, the better to portray his mural subject: religion. This period of travel, which lasted a year, included stops at Athens and Constantinople, where he produced a few watercolors. The Sargent family returned through San Remo, staying at the Villa Ormond. The artist then attended Violet's wedding to Francis Ormond in Paris and returned to England fall 1891. There, he occupied himself almost exclusively for the next couple of years with the mural project. He shared a studio with Abbey at Morgan Hall, Fairford, in Gloucestershire, where the two artists, each in his own space, worked at the enormous task, hiring models and assistants, organizing props and costumes, and making numerous sketches and studies. A few landscapes and interiors were done, including the luscious *Still Life with Daffodils* (Plate XLVII), a richly brushed, informal table-top still life.

It was not until the Royal Academy Exhibition of 1893 that Sargent surfaced publicly and in a big way. The portrait of Lady Agnew (National Gallery of Scotland, Edinburgh) was a sensation. There was nothing like it to be seen. No one, public or critic, could deny its brilliance or importance. The *Times* called it a masterpiece.[58] In the following year, Sargent was elected to the Royal Academy, a surprise to many considering his age and avant-garde connections (the New English Art Club).

Lady Agnew transcended all objections. The work was Sargent's own creation, his synthesis of Impressionism and realism. She is seated casually, leaning back in a floral *bergère* and gazing directly at us. The head is carefully rendered, sensitive to the barely perceptible nuance of a slightly uplifted left corner of the mouth and brilliantly modeled by tonal values. The cream dress, violet sash, and Japanese silk wall hanging create a near-Whistlerian harmony but are not done with that painter's premeditated sense of design. They are local colors painted with the eye of an Impressionist, the naturalistic light falling from the upper left, illuminating the beautiful head and broadly brushed fabrics. It is the realistic light effects, learned from Impressionism, that give the figure its life, its existence in real space, and its sense of immediacy. Gone is the harshness of studio lighting learned in Paris. The effects of natural light, real light, were understood by the perceptive reviewer in the 1893 *Art Journal*:

> He has shirked no difficulty in the problem before him of modeling the actual form and nuancing the real color as light models and shades it.
> He has sought refuge in no cheaper solvent of tonality, whether brown, blue, or gold. . . . His brushwork boldly challenges you by presenting a definite tone for every inch of surface . . . he never permits some pleasantly warmed juice to veil his view of air, color and form.[59]

This technique, this synthesis of Impressionism and realism, was to characterize his portraiture throughout his career. The same Impressionist effects are seen fourteen years later, in 1907, in the portrait of the stunning duchess of Sutherland (Collection Baron H. H. Thyssen-Bornemisza, Lugano, Switzerland), the head accurately rendered in tonal values, the garden setting painted in broad, brilliant strokes, sunlight dappling through the trees with the same effects of Renoir's *La Balancoire*.

The 1890s were dominated by Sargent's own success. "During these years, the nineties, it had ceased to be a question who would be painted by Sargent; the question was whom would he find time to paint."[60] Inundated by portrait

commissions and the burden of the murals, it was not until the end of the decade that he could find time for outdoor painting in a regular way. His painting in oil of nonportrait subject matter from the late 1890s to his death was a synthesis of the high-key Impressionist palette and creamy, skillful, and spirited brushwork. The resulting technique was entirely his own.

Sargent carried on his Impressionism more directly in another medium—watercolor. It is here that the artist manifested his fascination with painting *en plein air*. In 1892, Sargent executed several spontaneous and freely brushed street scenes in Spain. The rapidity of the brushwork relates to the same technique used in 1890 in watercolor in Worcester: rapidly indicated, vigorous strokes. After 1900, watercolor became a seasonal event. Every summer in Venice for a dozen years, Sargent rejoiced in painting the myriad-hued reflections in the canals, the violet outlining the buildings in the bright blue sky, the quickly sketched, naturally posed figures in the prows of boats, the gondolas silently streaking past the Rialto bridge, and the effects of the brilliant Venetian light on the architecture of that dazzling city. In Florence, Siena, Rome, Spain, Corfu, Val d'Aosta, Purtud, and Carrara, he painted in watercolor, resulting in an inventory of his travels and chronology of his life. The pictures were not only personal statements, gifts to himself; they were his resolution of outdoor painting. They were his spontaneous, snapshot vision. They represent the culmination of his powers as an observer able to render quickly those effects of light and color that fell into his field of vision, without regard for composition or traditional balance. They were the free field for his eye in which he could run to paint as he saw it, life as it was before him, friends if he chose to, and, above all, color and the effect of light on it.

NOTES

1. Daniel Wildenstein, *Monet*, III (Lausanne, Paris: La Bibliothèque des Arts, 1979), letter 795, 223; original document, collection Mme. Howard-Johnston.
2. *Ibid.*, letter 794.
3. The precise dates and the number of visits that Sargent made to Giverny are not adequately documented. It seems likely that he made one of these visits during the summer of 1887. The Monet portrait at the National Academy of Design (Plate I) was exhibited at the New Gallery in May 1888, implying its 1887 date of execution. It is probable that Sargent visited Giverny on other occasions as well during 1884 to 1889. The date of 1887 for *Claude Monet Painting at the Edge of a Wood* (Plate II) is based on the portrait's date as well as on stylistic elements that seem to indicate that year.
4. Richard Ormond, *John Singer Sargent* (New York: Harper & Row, 1970), p. 41.
5. *Ibid.*, p. 16.
6. Evan Charteris, *John Sargent* (London: William Heinemann, 1927), p. 28.
7. John Rewald, *The History of Impressionism* (New York: Museum of Modern Art, 1961), p. 416, from Venturi Archives, vol. I, p. 115.
8. *Ibid.*, p. 404.
9. Charteris, p. 36.
10. Rewald, p. 374.
11. There or perhaps at St. Enogat. The precise location is uncertain, but in this context it is not especially relevant.
12. As examples: Monet, *Woman in a Garden, Springtime* (1875, Walters Art Gallery, Baltimore); Renoir, *Madame Monet and Her Son in Their Garden at Argenteuil* (1874, National Gallery of Art, Washington, D.C.); Manet, *On the Beach* (1873, Louvre, Paris).
13. Charteris, p. 130.
14. Rewald, p. 95.
15. David Park Curry, *James McNeill Whistler at the Freer Gallery of Art* (New York: Norton, 1984), p. 80.
16. *Ibid.*, p. 80.

17. *Ibid.*

18. *Ibid.*, from Charles Baudelaire, "The Painter of Modern Life," in *The Painter of Modern Life and Other Essays*, trans. Jonathan Mayne (London: 1964), p. 9.

19. *Ibid.*, p. 81.

20. Edmond Duranty, "The New Painting," in Linda Nochlin, *Impressionism and Post-Impressionism, 1874–1904* (Englewood Cliffs, N.J.: Prentice-Hall, 1966), p. 7.

21. "If one now considers the person, whether in a room or in the street, he is not always to be found situated on a straight line at an equal distance from two parallel objects; he is more confined on one side than on the other by space. In short, he is never in the center of the canvas, in the center of the setting. He is not always seen as a whole; sometimes he appears cut off at mid-leg, half-length, or longitudinally." This refers to Degas but applies to Sargent as well in the Venetian pictures. Edmond Duranty, "La Nouvelle Peinture: À propos du groupe d'artistes qui expose dans les Galeries Durand-Ruel" (1876).

22. Ormond, p. 239, from *Gazette des Beaux-Arts* 27 (1883): 190, n. 46.

23. Rewald, p. 338. See L. Venturi, *The Aesthetic Idea of Impressionism*.

24. Rewald, p. 475.

25. *Ibid.*, p. 476, n. 57; H. Houssaye, article of 1882, quoted in C. H. Stranahan, *A History of French Painting* (New York: 1888), p. 463.

26. Trevor J. Fairbrother, "The Shock of John Singer Sargent's *Madame Gautreau*," *Arts Magazine* (January 1981): 96, n. 20.

27. Rewald, p. 488.

28. F. A. Sweet, *Miss Mary Cassatt: Impressionist from Pennsylvania* (Norman: University of Oklahoma Press, 1966), pp. 82–83.

29. Charteris, p. 77.

30. *Ibid.*, p. 78.

31. *Ibid.*, p. 129: "Ainsi les fleurs sont plus jolies par temps gris."

32. The sitter appears to be Flora Priestly but is not documented as such.

33. The dating of these floral paintings—1885 or 1886—is difficult to determine. Sargent was in Broadway in August and September of both years and thus had the opportunity to do many paintings of blossoming roses.

34. Joyce A. Sharpey-Schafer, *Soldier of Fortune: F. D. Millet* (Utica, N.Y.: 1984), p. 89.

35. Charles Merrill Mount, *John Singer Sargent, a Biography* (New York: Norton, 1955), p. 84, extract from a letter to a friend.

36. Letter, Joyce A. Sharpey-Schafer to Donna Seldin, January 3, 1983.

37. Ormond, p. 40.

38. *Art Journal* (1887): 248 (from Ormond, p. 40).

39. *Supra*, n. 2.

40. Richard Ormond and James Lomax, *John Singer Sargent and the Edwardian Era* (London: Leeds Art Galleries and National Portrait Gallery, 1979), p. 44.

41. Charteris, p. 97.

42. Ormond, p. 41.

43. Frances Weitzenhoffer, "The Earliest American Collectors of Monet," in *Aspects of Monet: A Symposium on the Artist's Life and Times* ed. John Rewald and Frances Weitzenhoffer (New York: Abrams, 1984), p. 87.

44. Claire Joyes, *Claude Monet at the Time of Giverny* (Marais: Centre Culturel des Marais, 1983), p. opp. fig. 27.

45. Charteris, p. 96.

46. This painting was reinscribed in 1951 *Broadway, 1885*. Both place and date are erroneous.

47. Charteris, p. 101.

48. Carter Ratcliff, *John Singer Sargent* (New York: Abbeville Press, 1982), p. 118.

49. *The Magazine of Art* 12 (1889); *The Chronicle of Art*, "Art in May": xxix.

50. *The Art Interchange*, "Art Notes" 24, no. 6 (March 15, 1890).

51. Charteris, p. 102.

52. Ormond and Lomax, fig. 14.

53. Ormond, p. 42.

54. Fairbrother, 93.

55. Rewald, p. 486.

56. Mount, p. 157.

57. Charteris, p. 103.

58. Ormond and Lomax, p. 56.

59. Ormond, p. 46.

60. Charteris, 140.

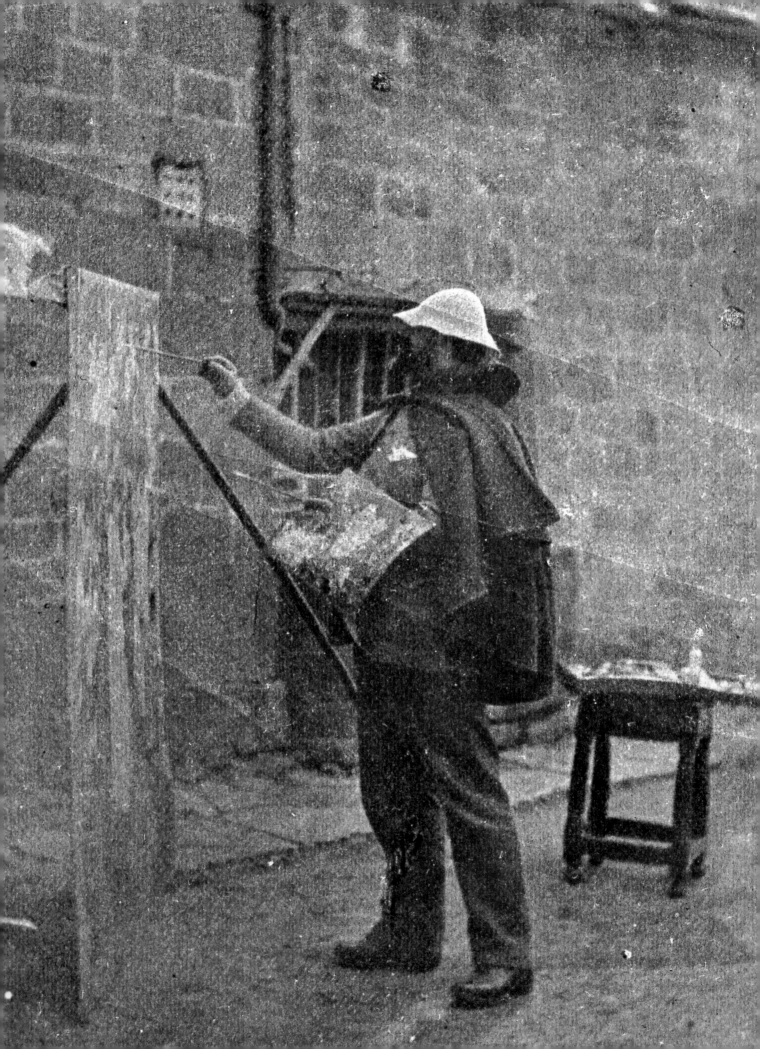

Carnation, Lily, Lily, Rose

by Richard Ormond

*C*arnation, *Lily, Lily, Rose* (Plate XIX) is the third of Sargent's major early subject pictures. Though formalized compositions, all grew out of a particular phase of experimental work. We owe *The Oyster Gatherers of Cancale* to Brittany and Sargent's first steps in plein-air painting. *El Jaleo* (Isabella Stewart Gardner Museum, Boston) celebrates Spain, Spanish dancing, and Velázquez. *Carnation, Lily, Lily, Rose* is England and Impressionism. It differs from its predecessors in having been painted largely outdoors rather than in the studio, but its period of gestation was similarly protracted. *Oyster Gatherers* was exhibited in 1878 from sketches made in 1877. *El Jaleo* was exhibited in 1882, two and a half years after the journey that inspired it. *Carnation, Lily, Lily, Rose*, whose exhibition followed after a further gap of five years in 1887, was just under two years in the making. Like *El Jaleo*, the picture proved far more demanding and time-consuming than Sargent could have envisaged when he began it. It was his hostage to fortune during a difficult period of transition. Like the earlier picture, it triumphantly justified the immense amount of effort put into its production, joining the select list of Sargent show-stoppers.

 Carnation, Lily, Lily, Rose represents two young girls in white in the act of lighting Japanese lanterns in a garden at twilight. They hold the bases of the lanterns while carefully inserting tapers to avoid burning the paper sides. The other lanterns, suspended in a circle on a string, looped from one rose stem to another, are already gleaming like mysterious pink and orange moons. The girls, intent on the task of lighting the last pair visible in the picture, are briefly quiet. In a moment they will dance away with girlish effervescence—for lanterns mean parties, in this case a summer party in the open air. Dressed in yoked party frocks, with frilly collars, cuffs, and hems, their faces lit up by the reflected light from the lanterns, they lend an air of suppressed excitement to the scene.

 The use of Chinese lanterns, often octagonal in shape with solid sides, can be traced back to the eighteenth century and the vogue for Chinoiserie. They were used with notable effect in the lighting of the Brighton Pavilion. Though sometimes called Chinese lanterns, the concertina paper examples in Sargent's picture are, in fact, Japanese. From the 1870s, they were imported in large quantities, and they are associated with the Aesthetic movement. Together with Japanese fans, blue-and-white china, and lacquer screens, they contributed to the distinctive Oriental flavor of the new style, though necessarily an ephemeral part of it. On sale in London at Liberty's, that emporium of Aestheticism, they gained wide currency as a form of lighting for special occasions and remained popular until the end of the century. They can be seen

Fig. 35
John Singer Sargent, *Teresa Gosse*, 1885.
Oil on canvas, 25″ × 19″. Private collection.

Opposite:
Sargent painting *Carnation, Lily, Lily, Rose* at Broadway (detail), c. 1885–1886.

63

illuminating a children's tea party in a painting of 1900 by the Irish Impressionist Walter Osborne (Fig. 34).

The Japanese lanterns form a central feature of Sargent's picture and contribute much to its exotic charm. They are placed in what appears to be the tangled border of a country garden. The girls are standing in a bed of red and white carnations, whose masses of gray-green leaves form the dominant vegetation of the foreground. A pink rosebush can be seen on the right, another of deep red on a tall stem above and between the girls, and more pink roses behind. Overtopping the figures and filling the upper ground of the picture are the distinctive trumpet shapes of arum lilies, drawn, as one reviewer remarked, "with singular boldness in half decorative style."[1] The picture is closed behind by the flat, undifferentiated green of a lawn, a device used in other landscapes of this period (Plate XXV), which serves to flatten the picture space and to accentuate its surface patterns.

It is well known that Sargent painted his picture outdoors in true Impressionist fashion, but the garden it represents is one of his own creation. No border in an English garden would include solely carnations, roses, and lilies—and certainly not in such a lavish and an unruly combination. The flowers he had selected to suit his decorative idea either would not grow or died too soon.

Fig. 34
Walter Osborne, *The Children's Party*, 1900. Oil on canvas, 21½″ × 30″.
By courtesy of Pyms Gallery, London.

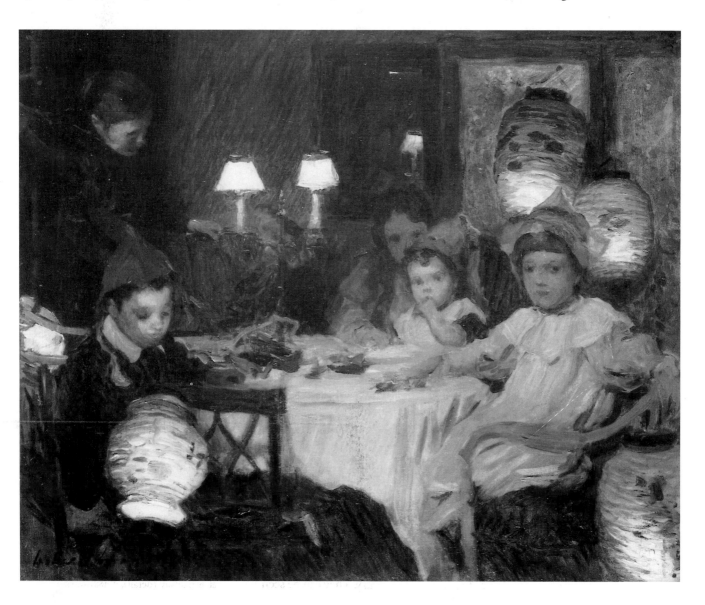

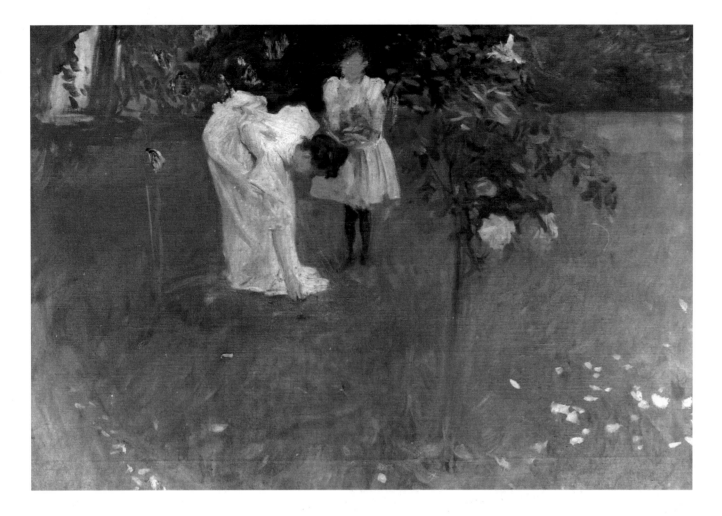

Fig. 36
John Singer Sargent, *Garden Study with Lucia and Kate Millet*, c. 1885. Oil on canvas, 24″ × 36″. Private collection.

He was forced by the exigencies of nature to bring in and plant the flowers of his choice. Enslaved by the title of his picture, he was confined to only carnations, roses, and lilies.

Sargent's exhibited subject pictures were invariably inspired by something he had seen. *Carnation, Lily, Lily, Rose* was no exception. We owe the explanation of its source to Edwin Abbey in a letter he wrote in September 1885, describing his journey with Sargent along the Thames: "Sargent . . . nearly killed himself at Pangbourne Weir. He dived off the same and struck a spike with his head, cutting a big gash in the top. It has healed wonderfully well, but it was a nasty rap. It was here that he saw the effect of the Chinese lanterns hung among the trees and the bed of lilies."[2] In a letter written in the same month to Edward Russell (an artist friend whom Sargent had met while they were both students of Carolus-Duran's), Sargent implied that he had seen the effect at Broadway itself: "I am trying to paint a charming thing I saw the other evening. Two little girls in a garden at dusk lighting paper lanterns among the flowers from rose-tree to rose-tree. I shall be a long time about it if I don't give up in despair."[3]

Pangbourne may have suggested the lanterns, but lilies had been on Sargent's mind at least since the summer of 1884, when he painted the Vickers children in a garden (Plate IX), an obvious rehearsal for the later picture. Roses were Broadway's inspiration. Sargent painted them in a sequence of studies— on bushes, in complex trellis patterns, and cut, as elements of still life (see Plates XXII, XXIII, XXIV, and XXV). The little girls of the colony he painted, too: Kate Millet, his first choice of model for *Carnation, Lily, Lily, Rose*; Teresa

Fig. 37
Photograph of Sargent painting *Carnation, Lily, Lily, Rose*, c. 1885–1886. Fogg Art Museum, Harvard University, Cambridge, Massachusetts (no. 1937.7.27, f. 1v). The artist appears to be painting in the lilies from a potted plant to his left.

Fig. 40
John Singer Sargent, study for *Carnation, Lily, Lily, Rose*, c. 1885. Oil on canvas, 23½″ × 19½″. Private collection.

Fig. 38
John Singer Sargent, sheet of studies for *Carnation, Lily, Lily, Rose*, c. 1885. Pencil, 9⅝″ × 13⅝″. Fogg Art Museum, Harvard University, Cambridge, Massachusetts (no. 1937.7.21, f. 12v).

Gosse (Fig. 35), daughter of author Edmund Gosse; and the two Barnard girls, Polly and Dorothy, daughters of artist Frederick Barnard.

Nothing seemed more natural than to combine the girls with the extravagant display of summer flowers which had captured his imagination. There was a touch of carnival at Broadway, of happy summer days and convivial evenings. The popular song by Joseph Mazzinghi that they were singing that summer of 1885, which Sargent tagged to his picture, seemed to sum it up:

> Did you see my Flora pass this way . . .
> Carnation, Lily, Lily, Rose.

Sargent arrived at Broadway in August 1885. By the twenty-fourth of that month, with Kate Millet as model, he was already launched on the big picture. Kate's Aunt Lucia wrote home in a letter of that date: "Mr John Sargent, a friend of his [Abbey's,] is painting in our garden and putting Kate in as the figure."[4] Lucia and Kate feature in a sketch of the time, gathering roses (Fig. 36). By September 6, a disconsolate Kate had been dropped in favor of the two Barnard girls—Polly, aged eleven, and Dorothy or Dolly, aged seven—because, it is said, the artist preferred the color of their hair.[5] Here is Lucia Millet again: "This week has been very busy and gay. Mr Sargent one of the artists here is painting the Barnard children in the garden and Mrs Barnard, her sister Mrs Faraday and I have been making them some white dresses to wear."[6]

Sargent's picture was growing more ambitious, with two figures in place of one. In late September or early October, Sargent wrote to his sister Emily: "I am launched into my garden picture and have two good little models and a garden that answers the purpose although there are hardly any flowers and I have to scour the cottage gardens and transplant and make shift. . . . Fearful difficult subject. Impossible brilliant colours of flowers and lamps and brightest green lawn background. Paints are not bright enough, and then the effects only last ten minutes."[7]

Sargent's decision to paint his models at twilight both added to the complexities of light and tone with which he had to contend and restricted his painting activity to a few minutes each day (Fig. 37). Edmund Gosse has left a vivid description of Sargent's evening ritual: "The progress of the picture . . .

when once it began to advance, was a matter of excited interest to the whole of our little artist-colony. Everything used to be placed in readiness, the easel, the canvas, the flowers, the demure little girls in their white dresses, before we began our daily afternoon lawn tennis, in which Sargent took his share. But at the exact moment, which of course came a minute or two earlier each evening, the game was stopped, and the painter was accompanied to the scene of his labours. Instantly, he took up his place at a distance from the canvas, and at a certain notation of the light ran forward over the lawn with the action of a wag-tail, planting at the same time rapid dabs of paint on the picture, and then retiring again, only with equal suddenness to repeat the wag-tail action. All this occupied but two or three minutes, the light rapidly declining, and then while he left the young ladies to remove his machinery, Sargent would join us again, so long as the twilight permitted, in a last turn at lawn tennis."[8]

Sargent remained at Broadway, apart from occasional visits to London and elsewhere, until the early part of November. He described his work on the picture in a letter of that time to Robert Louis Stevenson, whom he had recently visited and painted at Bournemouth: " 'Carnation, Lily, Lily, Rose' has brought me to bed of a picture, O God, most ugly just now. I saw a most paradisiac sight at the end of September [*sic*] instead of in June as I should have done. Children lighting paper lanterns swung from rose trees and in the middle of flowers, at dusk, when the lanterns just begin to glow. Now my garden is a morass, my rose trees black weeds with flowers tied on from a friend's hat and ulsters protruding from under my children's white pinafores. I wish I could do it! With the right lighting and the right season it is a most extraordinary sight and makes one rave with pleasure, and the theme in the abstract is charming and rather of a kind that I ranted about as only obtainable by an idiot. If I fizzle it will not be from any false pride about that theory."[9]

Before the end of the 1885 season, Sargent had certainly established the main lines of the final composition, though to what state he had carried the figures and landscape is far from clear. The genesis of the design can be followed in a sequence of drawings and oil sketches dating from his first season's work. Sargent's canvas was originally much longer, 7 or 7½ feet as opposed to its present 5 feet. A sheet from a sketchbook in the Fogg with four

Fig. 41
Letter, Sargent to his sister Emily, 1885. Ormond Family.

Fig. 42
John Singer Sargent, study for *Carnation, Lily, Lily, Rose*, c. 1885. Pen and ink, approximately 4¼″ × 5½″. Ormond Family.

Fig. 39
John Singer Sargent, sheet of studies for *Carnation, Lily, Lily, Rose*, c. 1885. Pencil, 9⅝″ × 13⅝″. Fogg Art Museum, Harvard University, Cambridge, Massachusetts (no. 1937.7.21, f. 11v).

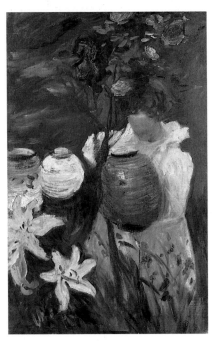

Fig. 43
John Singer Sargent, study of Dorothy
Barnard for *Carnation, Lily, Lily, Rose*,
c. 1885. Oil on canvas, 28½″ × 18½″.
Private collection.

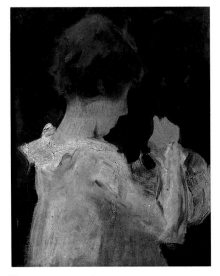

Fig. 44
John Singer Sargent, study of Polly Bar-
nard for *Carnation, Lily, Lily, Rose*, c. 1885.
Oil on canvas, 19½″ × 15½″. Ormond
Family.

Fig. 48
John Singer Sargent, study of a lily for
Carnation, Lily, Lily, Rose, c. 1885. Pencil,
9⅝″ × 13⅝″. Fogg Art Museum, Harvard
University, Cambridge, Massachusetts
(no. 1937.7.21, f. 10v).

thumbnail sketches (Fig. 38) records the Kate Millet phase with one figure
lighting a lantern. In successive sketches, she moves from the left side of the
design to the center and then to the right. A subsequent sheet with two
sketches (Fig. 39) records two figures on the right, both facing each other, but
with the short-cropped Polly to the right of Dorothy. In an early oil sketch
(Fig. 40), the two girls are back to back, Polly on the left facing out, Dorothy
facing in. A sketch in the letter from Sargent to his sister Emily, a passage from
which is quoted above (Fig. 41), depicts the two figures as they appear in the
final picture, facing each other but still in an extended composition.

Around the end of September and the beginning of October 1885, Sargent
decided to reduce the proportions of his picture almost to that of a square
(68½ × 60½ inches), cutting a strip of canvas approximately 24 to 30 inches
wide from the left-hand side of his canvas.[10] An early pen-and-ink drawing
(Fig. 42) records the new shape. The reasons for reducing the scale of the
composition may simply have been the result of the problems Sargent was
experiencing in painting the flowers and foliage: he wanted to paint less. The
effect of the reduction is, of course, to focus attention on the two figures, who
now occupy the center of the stage, instead of attempting the more ambitious
balancing act between figures and landscape.

Later oil and pencil studies for the figures record the process of refine-
ment in the poses and treatment of the models. There is an oil sketch for the
figure of Dorothy (Fig. 43) and close-up heads in oil of both Polly and
Dorothy (Figs. 44 and 45; Plate XVIII), as well as the beautiful pencil sketches
in the Tate Gallery (Figs. 46 and 47), from which the faces in the finished oil
were taken. There are also pencil studies of flowers and lanterns in the Fogg
sketchbook (Figs. 48 and 49).

During the dead months of 1885–1886, the picture remained in storage at
Broadway, but it was not forgotten. In April 1886, Sargent sent fifty lily bulbs to
Lucia Millet at Russell House, Broadway, to which the Millets had moved
recently from Farnham House. "I am to put 20 in pots and force them for his
big picture, the others are to be in the garden anywhere I like."[11] When the
time came to begin work on the picture in late August or early September 1886,
a special flower bed had been cut in the garden of Russell House, and,

according to Evan Charteris, "the country was ransacked for roses, carnations and lilies. Sargent, chancing on half an acre of roses in full bloom in a nursery garden at Willersey, said to the proprietor: 'I'll take them all, dig them up and send them along this afternoon.' "[12]

The American artist Edwin Blashfield, who had joined the colony for the summer, wrote home on September 7, 1886: "Three [*sic*] pretty children running about are called up about ¼ to 7 by Sargent who installs a big canvas, which he brings on his back from his studio—thereupon the lawn he continues to paint a charming evening effect which he is doing on all fine nights from the Barnard Children Pollie and Dollie who pose very patiently. Altogether it makes such a pretty sight."[13] It is Blashfield again who documents the fits and starts by which the picture went forward: "Each morning, when after breakfast we went into the studio, we found the canvas scraped down to the quick. This happened for many days then this picture daughter of repeated observation and reflection suddenly came to stay."[14] Sargent worked on the painting the second time round for only four or five weeks, as opposed to the ten or twelve weeks of the previous summer. By October 2, 1886, when Abbey mentioned it in a letter, Sargent's task was nearly done: "He [Sargent] has almost finished his large picture of the children lighting lanterns hung among flowers,—and has not begun anything else of importance this summer. We grew a great bed of poppies on purpose to paint, but it was too many for us, much the most intricate and puzzling affair I ever saw. I funked it entirely and gloated over the ineffectual struggles of Sargent, Millet, Alfred [Parsons] and Blashfield."[15]

News of Sargent's picture began to filter out long before its first exhibition at the Royal Academy. The Royal Academician Henry T. Wells came to see it and told the artist that he would like to propose it for purchase by the Chantrey Bequest. In the hope of winning this prestigious honor, Sargent declined another offer for the picture.[16] The Chantrey Bequest, administered by trustees drawn from the ranks of the Royal Academy, bought one or two of the best contemporary works of art each year.

When the Academy opened in May 1887, Sargent's hopes were amply rewarded. The picture went straight to the hearts of the British public, it was well liked by the critics, and the Chantrey Bequest trustees selected it for

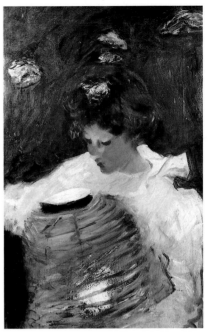

Fig. 45
John Singer Sargent, study of Dorothy Barnard for *Carnation, Lily, Lily, Rose,* c. 1885. Oil on canvas, 28½″ × 19½″. Private collection.

Fig. 46
John Singer Sargent, study of Dorothy Barnard for *Carnation, Lily, Lily, Rose,* c. 1885. Pencil, 11″ × 9¼″. Tate Gallery, London.

Fig. 49
John Singer Sargent, study of lanterns for *Carnation, Lily, Lily, Rose,* c. 1885. Pencil, 9⅜″ × 13⅝″. Fogg Art Museum, Harvard University, Cambridge, Massachusetts (no. 1937.7.21, f. 11r).

Fig. 47
John Singer Sargent, study of Polly Barnard for *Carnation, Lily, Lily, Rose*, c. 1885. Pencil, 9¾″ × 8¼″. Tate Gallery, London.

Fig. 53
James McNeill Whistler, *Symphony in White No. III*, 1867. Oil on canvas, 20½″ × 30⅛″. Barber Institute of Fine Arts, University of Birmingham.

purchase. After the hostility that so much of Sargent's painting had aroused in England, the chorus of praise must have been music to his ears. Here was a narrative picture in a tradition that the English could understand, and they overlooked its daring, experimental qualities for the pleasure that they took in its subject. The review by Harry Quilter in the *Spectator* is typical: "He has succeeded in painting a picture which, despite the apparent *bizarrerie* of its subject, despite the audacious originality with which he has treated it, is purely and simply beautiful as a picture. The introduction and painting of the children's figures, the disposition of the masses of flowers and leaves with which they are surrounded, the delicately bold colouring of the roses, lilies, and carnations,—in all of these respects is this picture an exquisite work of art. And even now we have left its chief merit untold, and must leave it undescribed; for how is it possible to describe in words that subtle rendering of brilliance and shadow, that united mystery and revelation, which render this composition so admirable?"[17]

The idea of the enclosed garden and the identification of women with this symbolism of flowers can be traced back to medieval romance. Botticelli's *Primavera*, one of the cult pictures of Aestheticism, is a complex pagan allegory on the theme of spring. Since the Renaissance, artists have depicted women as the embodiment of the seasons and the spirit of nature. In English art, a particular vein of sentiment has informed the pictures of very young girls, since the famous picture of the *Age of Innocence* by Sir Joshua Reynolds (Tate Gallery, London). Invariably dressed in white and placed in landscape settings, their youth and innocence has exerted a universal appeal. Miss Murray (Fig. 50)

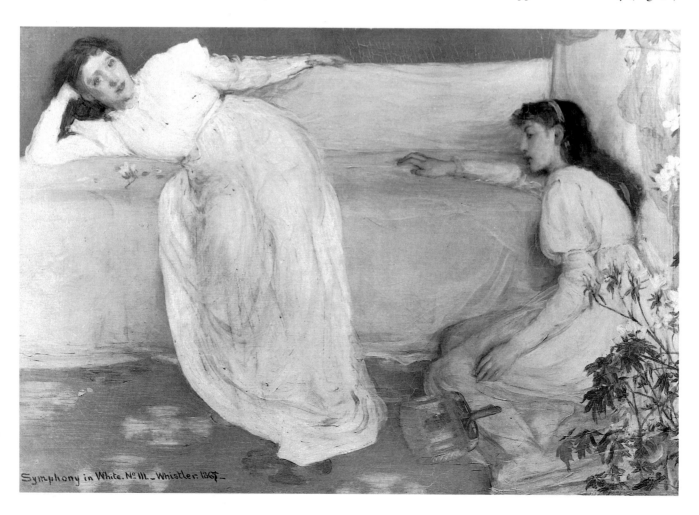

Symphony in White. No. III. Whistler 1867

dances a minuet in celebration of the season, her lap full of spring flowers, in Sir Thomas Lawrence's masterly romantic creation. There is a Mozartean cadence to this entrancing creature dancing in a ray of sunlight by the edge of a dark wood, so full of life and yet so transient.

The line that leads from *Miss Murray* to *Cherry Ripe* by John Everett Millais (Fig. 51) is very clear. Lawrence's descendants are a legion, and the image of girls in white in settings of landscape and flowers is very familiar in Victorian art. Millais made a speciality of them, consciously echoing the work of his predecessors like Reynolds in casting and costume, but endowing his

Fig. 50
Sir Thomas Lawrence, *Miss Murray*, c. 1826. Oil on canvas, 53½″ × 42½″. Iveagh Bequest, Kenwood, London.

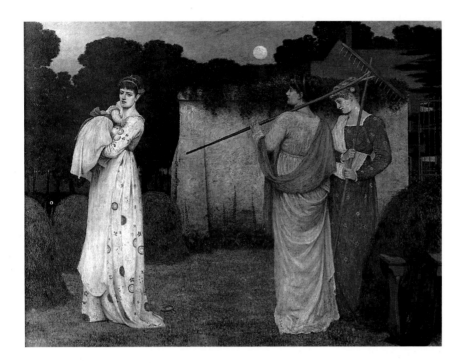

Fig. 54
Thomas Armstrong, *The Hayfield*, c. 1869. Oil on canvas, 44¾″ × 61⅞″. Victoria and Albert Museum, London.

models with a wholly contemporary flavor. Sargent was not a popularizer like Millais, but he cannot have been unconscious of the appeal which his picture would have for an English audience.

Cherry Ripe is a portrait of a single model to which the landscape is subservient. One would have to go back much earlier in Millais's career, to his Pre-Raphaelite masterpiece *Autumn Leaves* (Fig. 52), for a more telling comparison with *Carnation, Lily, Lily, Rose*. Four girls, two of them working-class, are putting leaves on a bonfire in the afterglow of a visionary sunset. The strangely intense appearance of the models and their identification with the poignant mood of season and hour contribute to a powerful, poetic effect.

Melancholy emotion and decorative arrangement are the hallmark of Aesthetic art. It was James McNeill Whistler rather than Millais who would become the high priest of Aestheticism. Millais turned away from the poetic vein of *Autumn Leaves* for a career as a popular narrative painter and landscapist. Whistler's *Symphony in White No. III* (Fig. 53) was painted eleven years after *Autumn Leaves*. Again, it is a picture of conscious design and melancholy mood but of wholly modernist sensibility. With its light tones, subtle color harmonies, and fluid touch, it breathes the same air as Sargent's picture and belongs to the same tradition. Thomas Armstrong's *Hayfield* of about 1869 (Fig. 54) provides a more conventional example of Aesthetic painting in a landscape context. Three statuesque women in flowing Grecian gowns, one

Fig. 51
Sir John Everett Millais, *Cherry Ripe*, 1879. Oil on canvas, 53″ × 35″. Private collection.

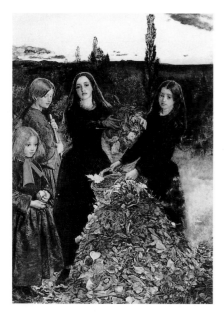

Fig. 52
Sir John Everett Millais, *Autumn Leaves*,
1856. Oil on canvas, 41″ × 29⅛″. City Art
Gallery, Manchester.

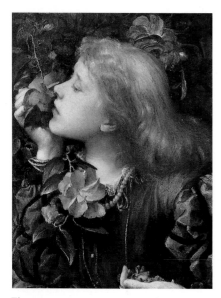

Fig. 55
George Frederick Watts, *Choosing*, 1864.
Oil on canvas, 18⅞″ × 13⅞″. National
Portrait Gallery, London.

gown with sunflower patterns, stand in a garden at twilight. Haymaking is merely an excuse for a decorative mood piece, a graceful arrangement of figures like a rural version of Albert Moore.

If Sargent's figures are demonstrably Aesthetic in inspiration, so, too, are his flowers. A delight with flowers as beautiful objects and a concern with their symbolic attributes are characteristic of that trend of art for art's sake which so profoundly affected English painting in the second half of the nineteenth century. It is a trend that occurs in literature as well, and the lush, highly worked floral images of Aesthetic art find a parallel in the poetry of Tennyson and Swinburne. Here is a stanza from Tennyson's "Maud":

> Queen rose of the rosebud garden of girls,
> Come hither, the dances are done,
> In gloss of satin and glimmer of pearls,
> Queen lily and rose in one;
> Shine out, little head, sunning over with curls,
> To the flowers, and be their sun.

The Victorians were passionate flower connoisseurs and knowledgeable about floral lore. Numerous little books were published expounding the meaning and attributes of flowers, a field of study that is alien to us now. The inclusion of a particular type of flower in a painting would have carried a connotation for a contemporary audience that we now either fail to recognize or misconstrue. The early Pre-Raphaelite picture by Charles Collins entitled *Convent Thoughts* (1850, Ashmolean Museum, Oxford) shows a nun contemplating a passion flower in a garden crowded with flowers. More than one recent critic has misinterpreted the evidence as a conflict between sensual and spiritual love. In fact, the inner shape of the passion flower is associated with the nails of the cross, and the nun is engaged in mystical contemplation of the Crucifixion, the type of subject you would expect from an artist who was a devout Christian.

George Frederick Watts's *Choosing* (Fig. 55) shows his young bride Ellen Terry in the act of smelling a camelia while holding a bunch of violets. Camelias are scentless while violets are sweetly perfumed, and the subject of this work has been interpreted in the twentieth century as being a choice between worldly vanity and domestic affections. Looking in your book of flowers, you will find that camelias do not stand for worldliness but for "unpretending excellence," violets for faithfulness. Ellen Terry's problem was whether to scale the heights of her chosen profession as an actress or to remain with the modest violets of her marriage to Watts.

Flower symbolism as specific as the two examples quoted above is perhaps the exception rather than the rule. Like Sargent's picture, the figures and flowers in John Frederick Lewis's *Lilium Auratum* of 1872 (Fig. 56) form part of an intermingled, luxuriant design. The lilies of the title overtop the two girls in their exotic Arab costumes, and roses, poppies, pansies, fuchsias, and tulips contribute to a riot of patterns and colors. The effect in Lewis's bright, hard-edged style is almost overwhelming, where Sargent's Impressionism is soft and luminous. Frederick Walker, who died young and is undeservedly neglected, represents a bridge between the pastoral tradition of English landscape and the Aesthetic-cum-classical-values of figure composition. His picture *Lilies* (Fig. 57), painted in the same decade as *Lilium Auratum*, juxtaposes the girl and the vista of garden in a more meaningful way. We are led to speculate on the life and character of the girl, as revealed in the tender way she seeks solitude in watering the flowers.

Walker and Lewis are naturalist painters. Flower symbolism reaches its apogee in the idealist art of the true Aesthetes. Flowers weave in and out of the painting of Edward Burne-Jones, performing a symbolic function as attributes of a story or character, and as decoration for his bold, repetitive designs. Many of his late works were carried out in the medium of tapestry, including the famous Holy Grail series. Sargent was an ardent admirer of Pre-Raphaelite art in general and of Burne-Jones's work in particular. *Flora* (Fig. 58) is an example of the type of richly worked tapestry design, picked out with flowers of every variety, including lilies and carnations, that represent a stylized parallel to the flat verdure and patterned flower arrangements of *Carnation, Lily, Lily, Rose*.

Red carnations traditionally represent betrothal, roses are for love, lilies for purity. With sunflowers, they were the flowers especially dear to the hearts of the Aesthetes. Though Sargent may not have intended the flowers to have a precise meaning as far as the subject of his picture is concerned, he plays on the poetry and sentiment attached to them with deliberate effect.

Carnation, Lily, Lily, Rose is unmistakably English in its associations and its extravagant floral display. Other artists of the colony were attracted to the gardens and countryside in and around Broadway. Millet and Abbey painted and drew country scenes, and competed with Sargent in painting poppies, together with Alfred Parsons, whose *"When Nature Painted All Things Gay"* (Fig. 59) was exhibited at the Royal Academy the same year as Sargent's picture was, and was similarly purchased for the Chantrey Bequest. Parsons was a flower painter whose work relates to the Victorian tradition of idealized

Fig. 57
Frederick Walker, *Lilies*, c. 1868. Untraced watercolor.

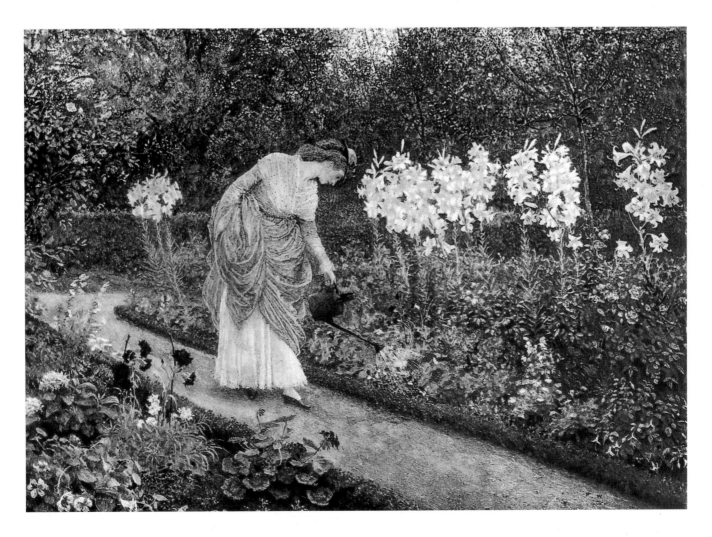

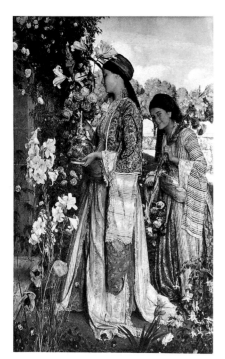

Fig. 56
John Frederick Lewis, *Lilium Auratum*, 1871. Oil on canvas, 54″ × 34½″. City Museum and Art Gallery, Birmingham.

cottage scenes embowered in nature, exemplified in the work of Myles Birket Foster and Helen Allingham. Sargent's approach to art was wholly different, but it is interesting to see that it was the overpowering abundance and color of English gardens that attracted him. He rarely painted landscapes in England after 1889. It seems as if his interest in the lush, dreamy, claustrophobic atmosphere of the English scene evaporated with the ending of the first and more decorative phase of his Impressionism. When he returned to landscape after 1900, it was the clear light of the Alps and Italy that determined the strong contrasts of his late style.

Carnation, Lily, Lily, Rose is an Aesthetic arrangement of figures and flowers. It is also a triumph of plein-air painting, and one should not underestimate the countless ten minutes that Sargent devoted to it on summer evenings. We can feel the palpable reality of the ambivalent twilight, the glow of the lanterns, the warm flesh of the two girls' faces, and the tangled, mysteriously shadowed forms of leaves and flowers as the artist observed them. The picture has that same savor of modernity that makes Sargent's portraits so vital and real. The models are placed; the scene is set. Now all that the artist has to do is to record it.

The task of transcribing the immense variety of forms and tones must have seemed daunting. With so many strong points of interest, there was a danger of everything slithering from under his grasp. To capture the subtle shades of twilight is notoriously difficult for an artist. To do so when they are complicated by the reflections of an artificial light source on objects of vivid color is doubly so. In playing these complex and contradictory light sources against one another, Sargent faced a challenge that tested all his powers of observation and virtuosity to the full.

On first appearance the picture seems to be composed from a rich mosaic of carefully worked-up detail. What is remarkable, in fact, is the quantity of detail that has been suppressed. The figure of Polly on the left is schematic; the lilies are detached trumpet shapes with no stems; rose bushes are flatly patterned shapes of green with pink highlights; a few bold individual strokes define the tangled pattern of leaves in the foreground. The impression of elaboration, of dense crowded forms, was achieved by slender means. The artist simply translated onto a larger scale the slight, suggestive qualities of his

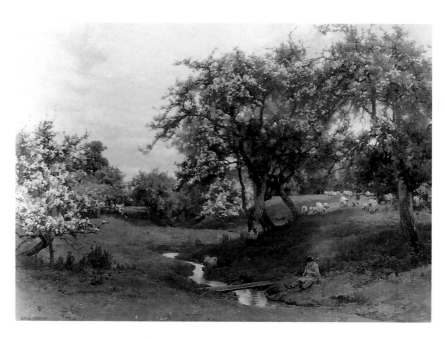

Fig. 59
Alfred Parsons, *"When Nature Painted All Things Gay,"* c. 1887. Oil on canvas, 41½″ × 59½″. Tate Gallery, London.

flower sketches, the flicker of leaves and pink roses on thinly washed, luminous, flat backgrounds. If the picture became overworked, it would lose its freshness and vibrancy. The constant scraping down described by Blashfield was required to combine unity of impression with immediacy of touch. A comparison with Monet's *Women in a Garden* (Fig. 60), a similarly decorative arrangement of figures in white in a light-filtered garden, demonstrates clearly the sources of Sargent's style in the visual experiments and pleasures of Impressionism.

NOTES

1. "Academy," *"Royal Academy"* 31 (May 21, 1887): 369.
2. E. V. Lucas, *Edwin Austin Abbey* (1921), I, p. 151.
3. Tate Gallery Archive, London.
4. Letter of August 24, 1885, private collection.
5. A group portrait of the Barnard sisters and their brother, Geoffrey, by their father Frederick Barnard was exhibited at the Royal Academy in 1884 (no. 1564). It is untraced, but a pen-and-ink sketch after it is reproduced in *Academy Notes* (1884).
6. Letter of September 6, 1885, private collection.
7. Facsimile of letter reprinted in Evan Charteris, *John Sargent* (London: William Heinemann, 1927), between pp. 76 and 77.
8. Charteris, pp. 74–75.
9. Letter of November 1885, Yale University Library, Stevenson Papers, RLS 5427.
10. According to C. M. Mount, *John Singer Sargent* (1955), p. 112, Sargent used the strip of canvas for the first version of the portrait of Mrs. Barnard holding a teacup (private collection, North Carolina). The dimensions of this portrait are 41 × 30 inches, and flowers, possibly roses, are visible below the present paint surface. Abbey described the original dimensions of *Carnation, Lily, Lily, Rose* as 5 × 7 feet. In fact, the Tate picture is over 5½ feet high, and the original length was probably 7½ feet. This would have given a width of 30 inches for the cut-off strip.
11. Letter of April 27, 1886, private collection.
12. Charteris, pp. 75–76.
13. New-York Historical Society.
14. *Commemorative Tributes to Cable by Robert Underwood Johnson, Sargent by Edwin Howland Blashfield, Pennell by John Charles Van Dyke* (New York: American Academy of Arts and Letters, 1926), p. 18.
15. Quoted in Lucas, I, p. 159. An oil sketch of poppies by Sargent was in Mrs. Millet's sale, Sotheby's, London, June 10, 1942, lot 88.
16. See *Illustrated London News* (October 24, 1904): 320.
17. Harry Quilter, "Spectator," *"Royal Academy"* (April 30, 1887): 591.

Fig. 58
Edward Burne-Jones, *Flora,* 1885. Tapestry.
Exeter College, Oxford.

Fig. 60
Claude Monet, *Women in a Garden,*
1866–1867. Oil on canvas, 100¼″ × 81¾″.
Musée du Louvre, Paris.

Plates

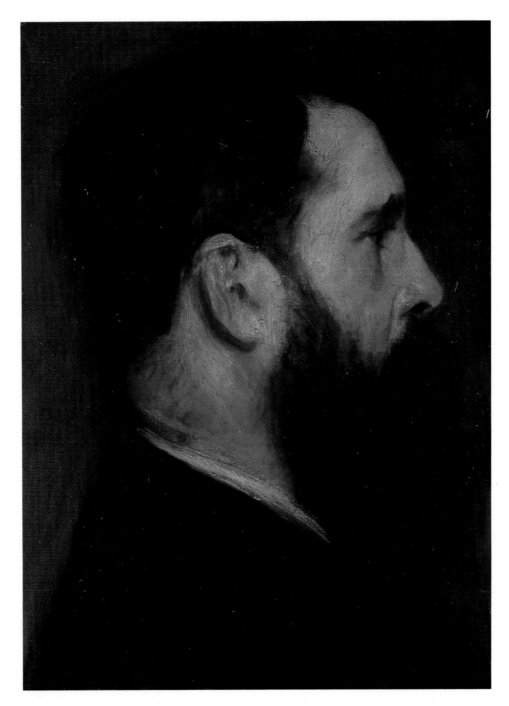

PLATE I
Portrait of Claude Monet, 1887
Oil on canvas, 16″ × 13″
National Academy of Design, New York

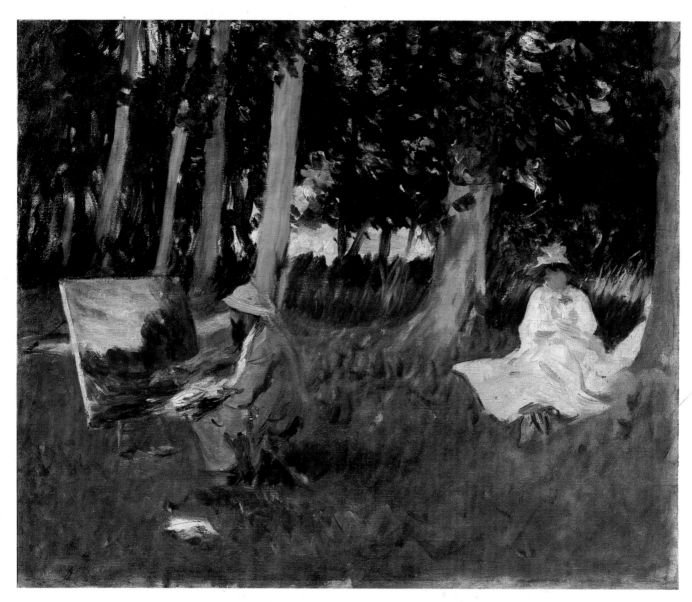

PLATE II
Claude Monet Painting at the Edge of a Wood, 1887
Oil on canvas, 21¼″ × 25½″
Tate Gallery, London

PLATE III
Gust of Wind, 1887
Oil on canvas, 24⅛″ × 15″
Private collection

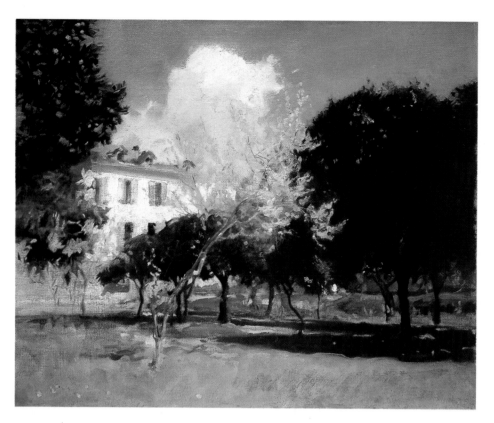

PLATE IV
House and Garden, c. 1883–1884
Oil on canvas, 22″ × 29″
Ormond Family

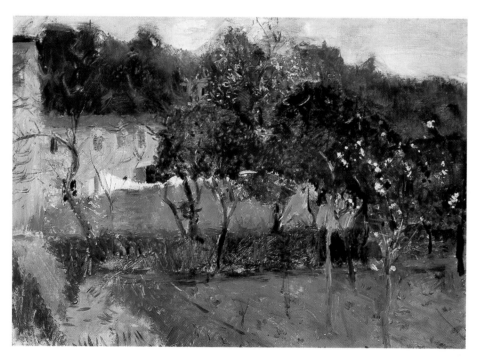

PLATE V
Nice, c. 1883–1884
Oil on canvas, 18¼″ × 25⅗″
Westmoreland County Museum of Art, Carolyn Lynch Memorial

PLATE VI
Thistles, c. 1883–1884
Oil on canvas, 22″ × 28¼″
Private collection

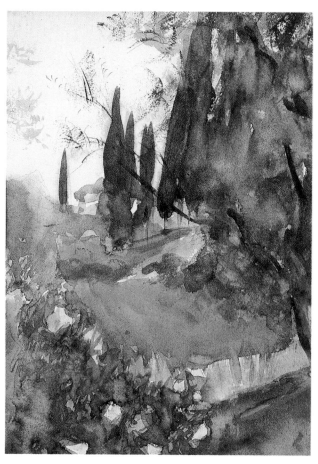

PLATE VII
Landscape with Cypresses, c. 1884
Watercolor, 13½″ × 9½″
Ormond Family

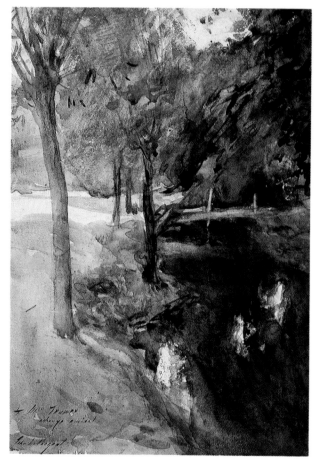

PLATE VIII
A Shadowed Stream, c. 1884
Watercolor, 14″ × 10″
Zoe Oliver Sherman Collection. Gift of Mrs. Henry H. Sherman.
 Courtesy, Museum of Fine Arts, Boston.

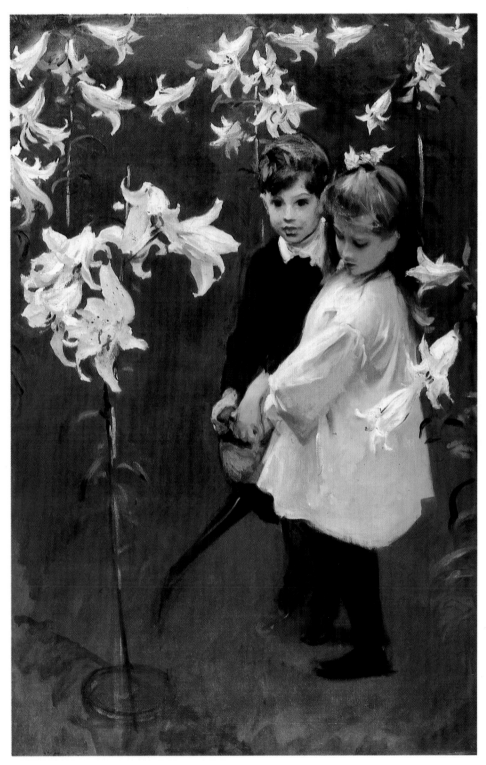

PLATE IX
Garden Study of the Vickers Children, 1884
Oil on canvas, 54 3/16″ × 35 7/8″
Flint Institute of Arts, Michigan, gift of the Viola E. Bray
 Charitable Trust

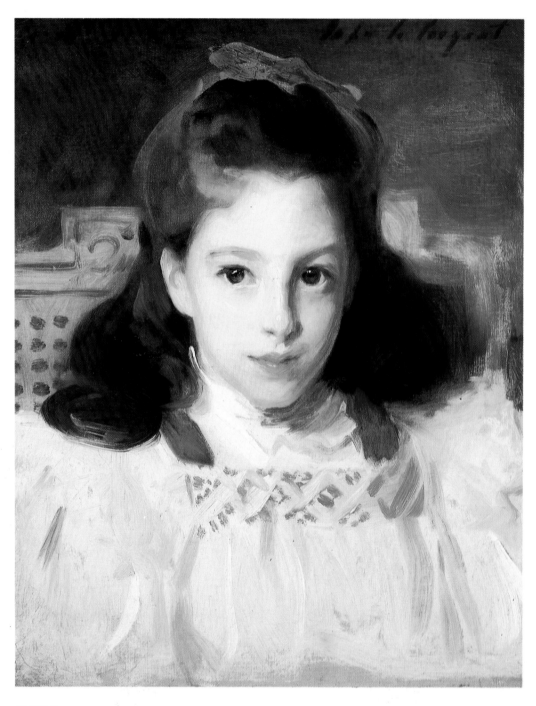

PLATE X
Portrait of Miss Dorothy Vickers, c. 1884
Oil on canvas, 18″ × 15″
Mr. and Mrs. Vincent A. Carrozza

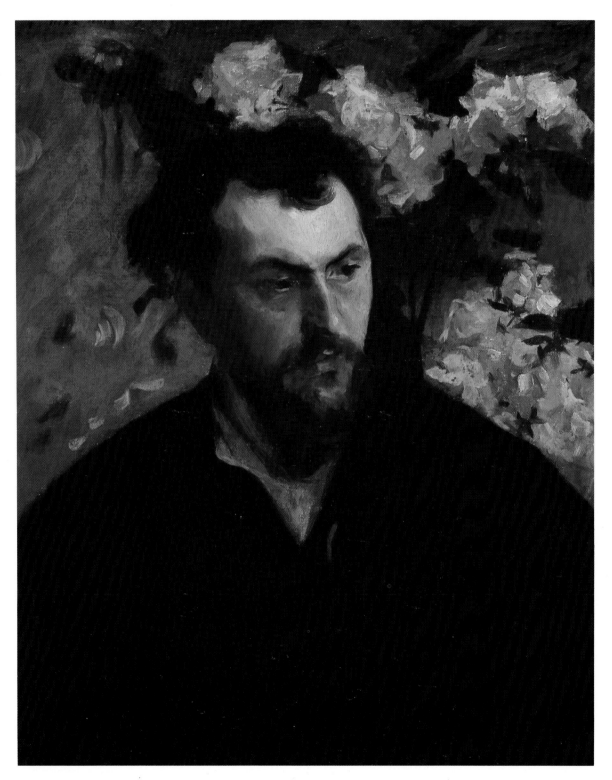

PLATE XI
Portrait of Ernst-Ange Duez, c. 1885
Oil on canvas, 29″ × 23¾″
Collection of the Montclair Art Museum, Montclair, New Jersey

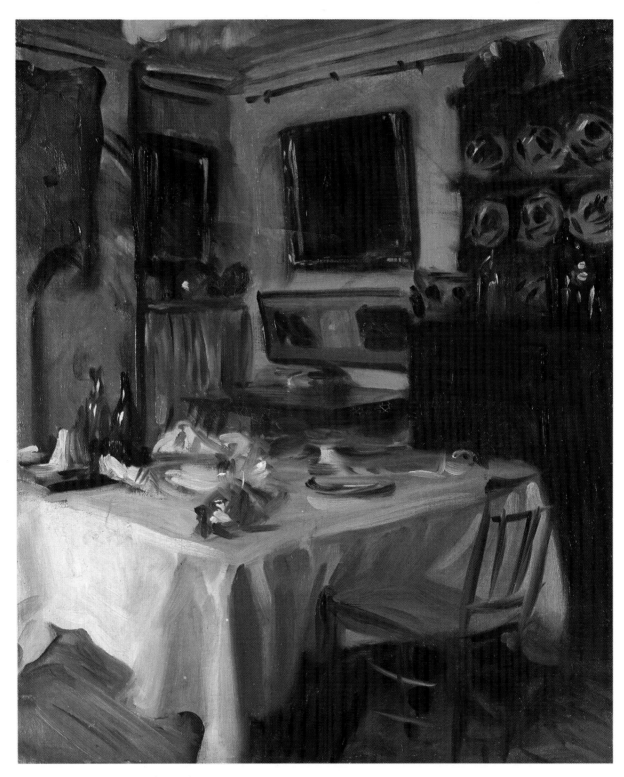

PLATE XII
My Dining Room, c. 1885
Oil on canvas, 29″ × 23¾″
Smith College Museum of Art, purchased with funds given by
 Mrs. Henry T. Curtiss (Mina Kirstein, 1918) in memory of
 William Allan Neilson, 1968

PLATE XIII
Home Fields, 1885
Oil on canvas, 28¾″ × 38″
Detroit Institute of Arts, City of Detroit Purchase

PLATE XIV
Landscape at Broadway, 1885
Oil on canvas, 18¼″ × 24¼″
Private collection

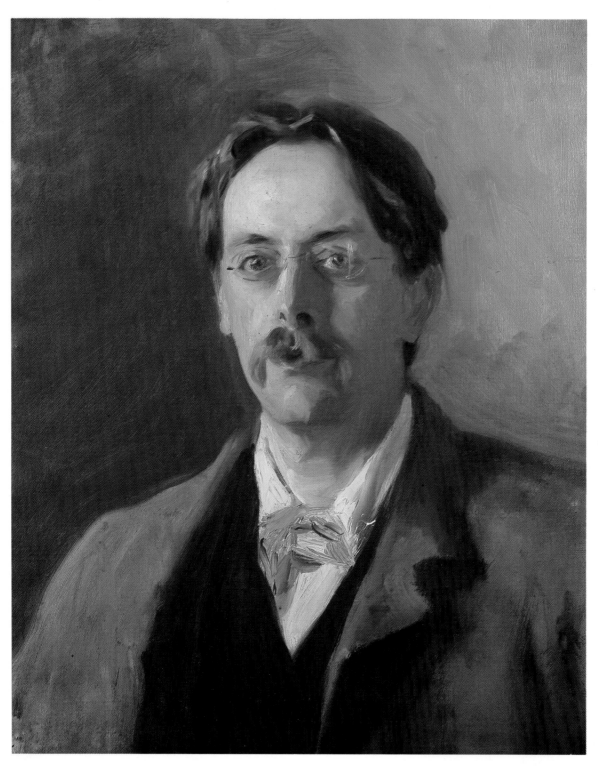

PLATE XV
Portrait of Sir Edmund Gosse, c. 1885–1886
Oil on canvas, 21½″ × 17½″
National Portrait Gallery, London

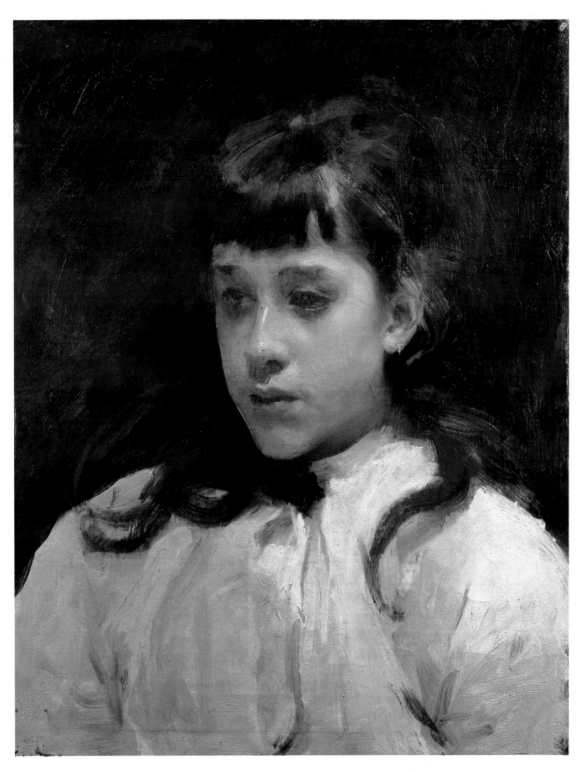

PLATE XVI
Young Girl Wearing a White Muslin Blouse, 1885
Oil on canvas, 19¼″ × 15″
Private collection

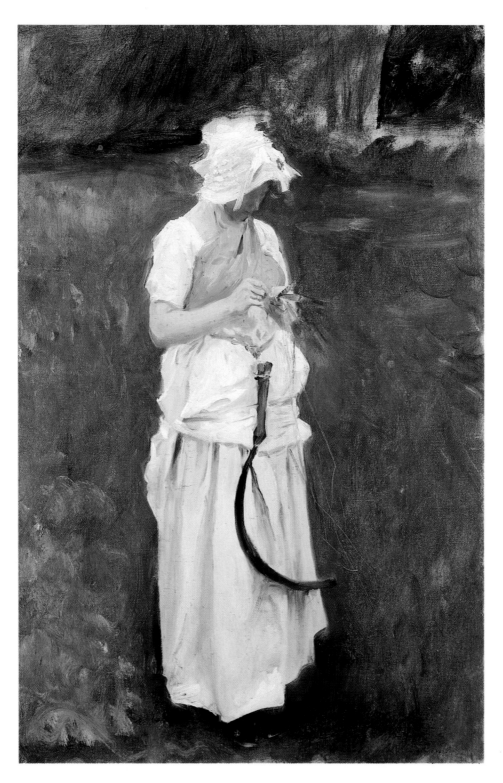

PLATE XVII
Girl with a Sickle, 1885
Oil on canvas, 23½″ × 15½″
Private collection

PLATE XVIII
Study of Polly Barnard for "Carnation, Lily, Lily, Rose," c. 1885
Oil on canvas, 19½″ × 15½″
Ormond Family

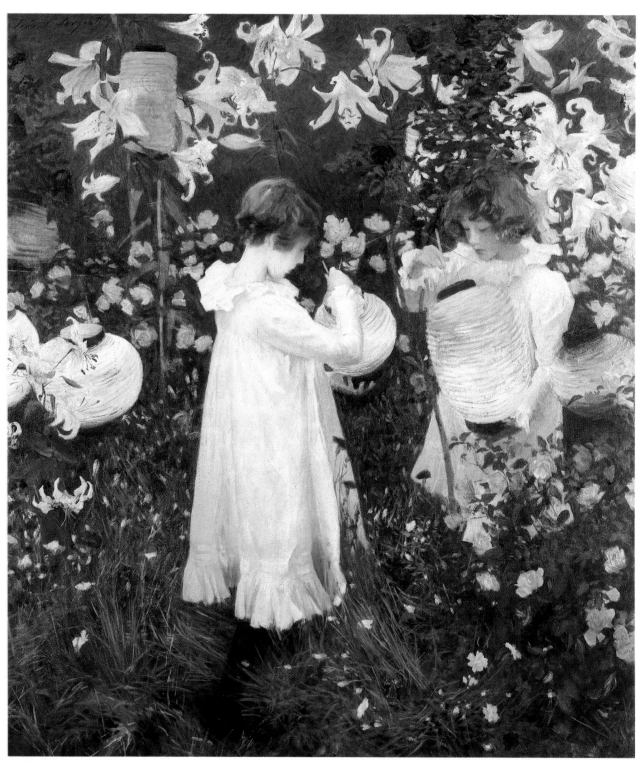

PLATE XIX
Carnation, Lily, Lily, Rose, 1885–1886
Oil on canvas, 68½″ × 60½″
Tate Gallery, London

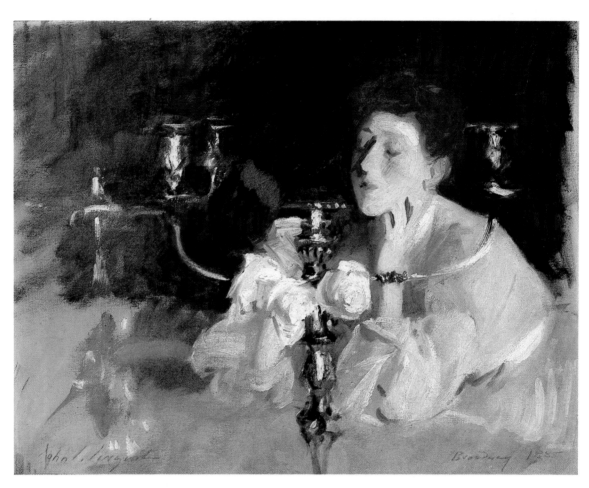

PLATE XX
The Candelabrum, 1885
Oil on canvas, 20¾″ × 26¼″
Private collection

PLATE XXI
The Millet House and Garden, 1886
Oil on canvas, 27″ × 35″
Mrs. John William Griffith

PLATE XXII
The Old Chair, 1886
Oil on canvas, 26½″ × 22″
Ormond Family

PLATE XXIII
A Rose Trellis, c. 1886
Oil on canvas, 27″ × 17″
Private collection

PLATE XXIV
Roses Lying on a Table, c. 1886
Oil on canvas, 9½″ × 21½″
Ormond Family

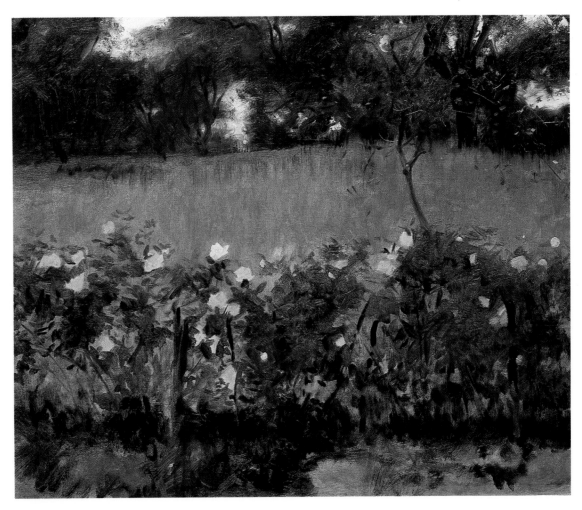

PLATE XXV
Landscape with Rose Trellis, 1886
Oil on canvas, 20½″ × 25″
Private collection

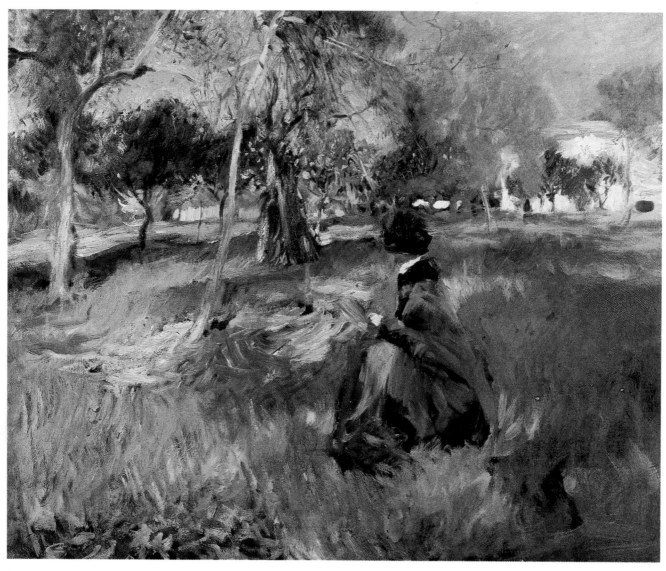

PLATE XXVI
In the Orchard, 1886
Oil on canvas, 24″ × 29″
Private collection

PLATE XXVII
Under the Willows, 1887
Oil on canvas, 26″ × 21″
Private collection

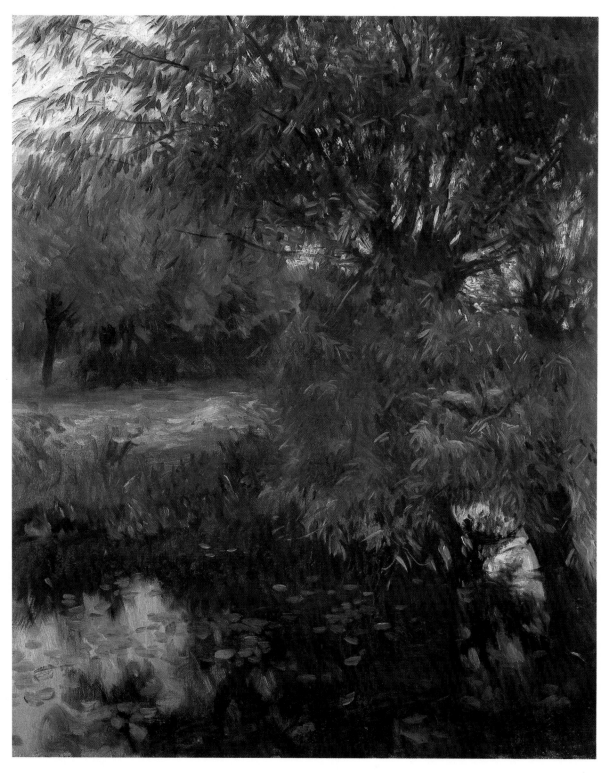

PLATE XXVIII
A Backwater at Wargrave, 1887
Oil on canvas, 29½″ × 24½″
Anonymous

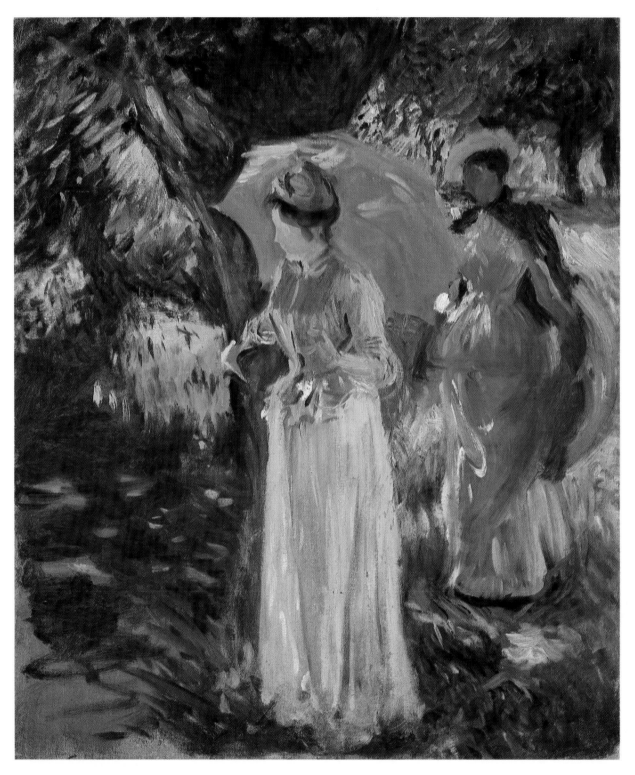

PLATE XXIX
Two Girls with Parasols, 1888
Oil on canvas, 29½″ × 25″
Metropolitan Museum of Art, gift of Mrs. Francis Ormond, 1950

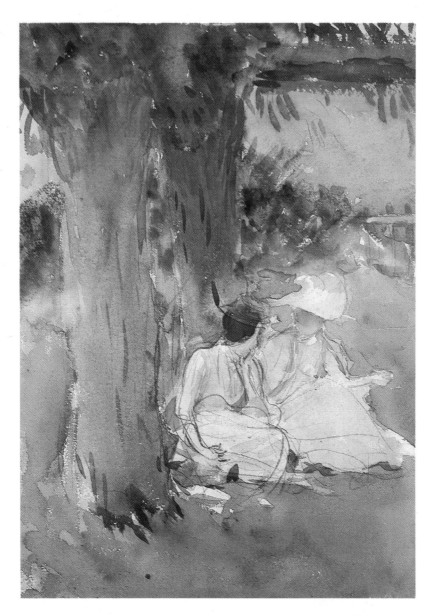

PLATE XXX
Under the Willows, 1888
Watercolor, 12½″ × 9⅛″
Collection of Mr. and Mrs. Raymond J. Horowitz

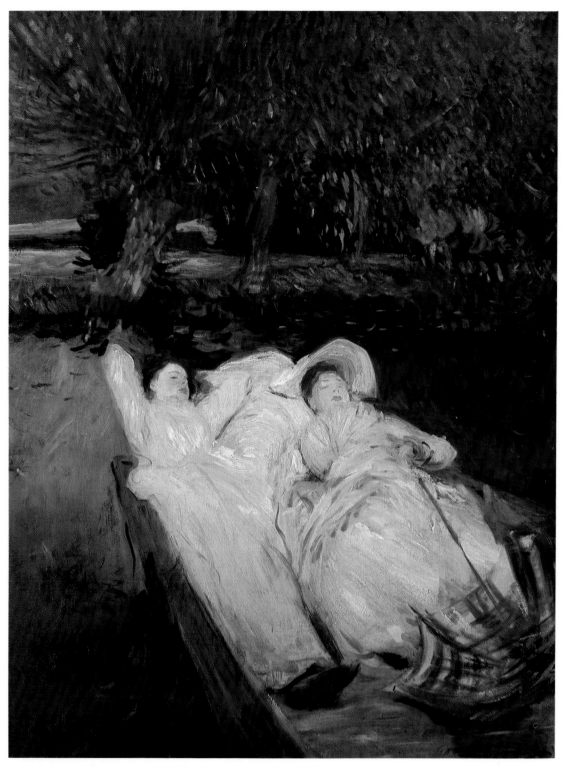

PLATE XXXI
Saint Martin's Summer, 1888
Oil on canvas, 36″ × 28″
Private collection

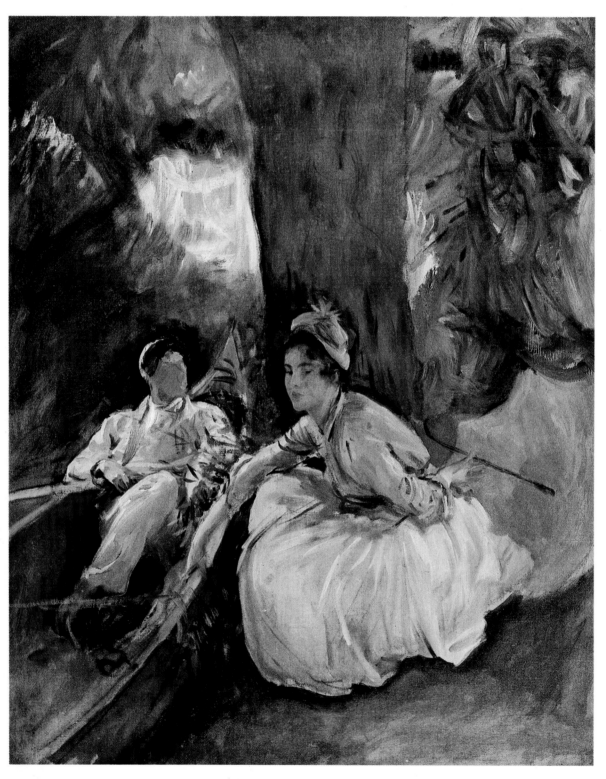

PLATE XXXII
By the River, 1888
Oil on canvas, 31″ × 25″
Private collection

PLATE XXXV
Two Girls Lying on the Grass, 1889
Oil on canvas, 21⅛″ × 25¼″
Metropolitan Museum of Art, gift of Mrs. Francis Ormond, 1950

PLATE XXXVI
Violet Resting on the Grass, 1889
Watercolor, 9¾" × 13½"
Ormond Family

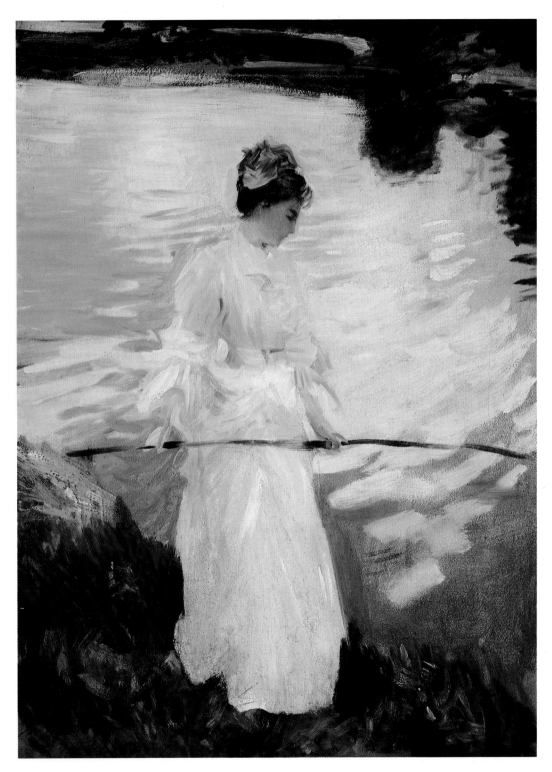

PLATE XXXVII
Violet Fishing, 1889
Oil on canvas, 28″ × 21″
Ormond Family

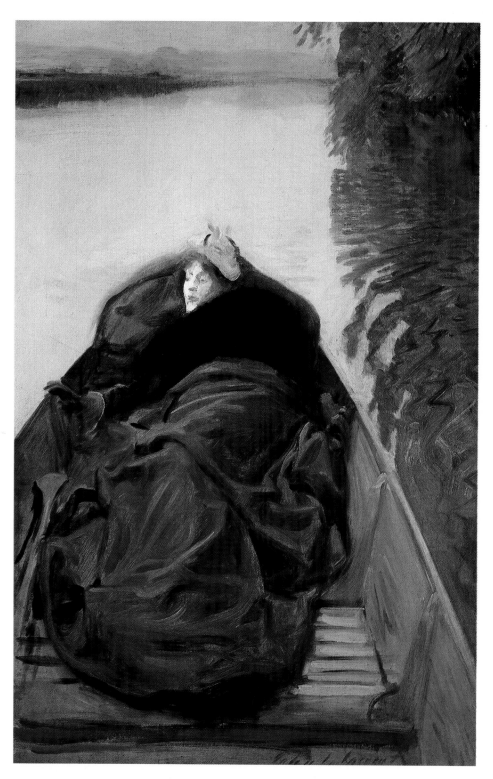

PLATE XXXVIII
Autumn on the River, 1889
Oil on canvas, 30″ × 20″
Private collection

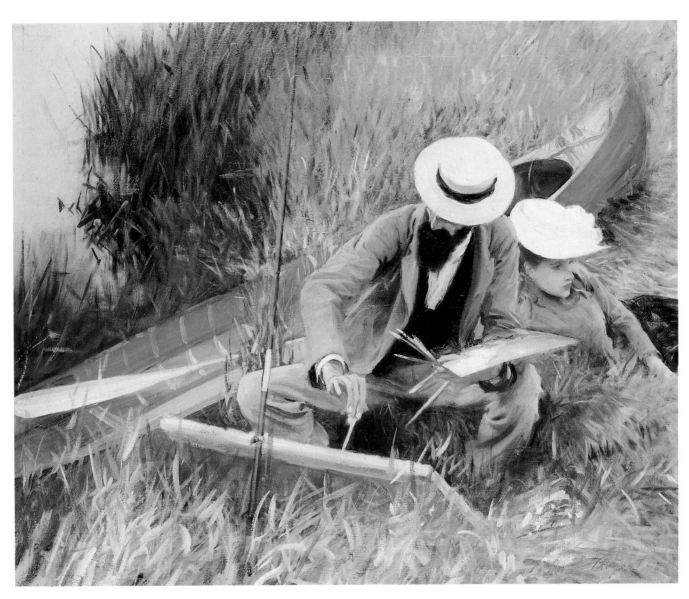

PLATE XXXIX
Paul Helleu Sketching with His Wife, 1889
Oil on canvas, 26⅛″ × 32⅛″
Brooklyn Museum, Museum Collection Fund

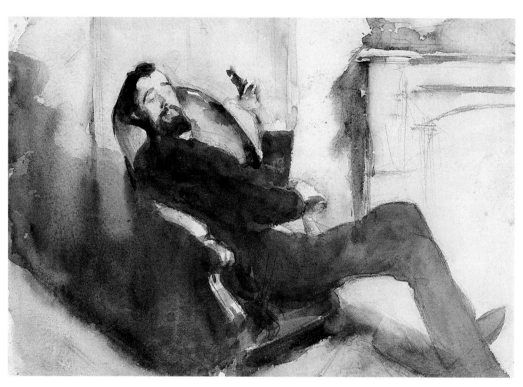

PLATE XL
Paul Helleu, c. 1889
Watercolor, 9¾″ × 13¾″
Ormond Family

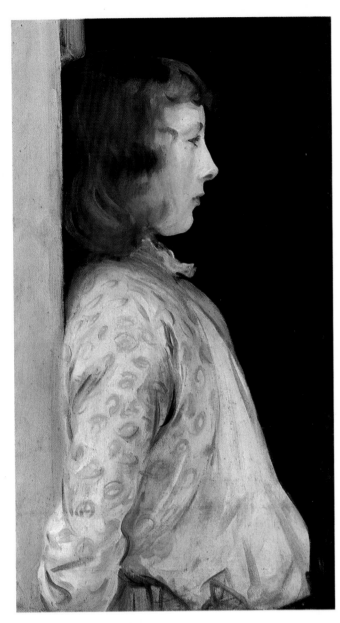

PLATE XLI
Portrait of Dorothy Barnard, 1889
Oil on canvas, 27¾″ × 15½″
Reproduced by courtesy of the Syndics of the Fitzwilliam
 Museum, Cambridge, England

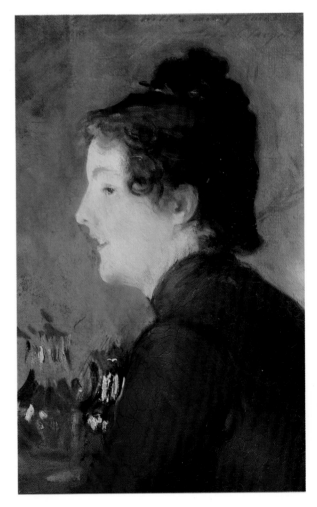

PLATE XLII
A Portrait of Violet, 1889
Oil on canvas; 23½″ × 15″
Ormond Family

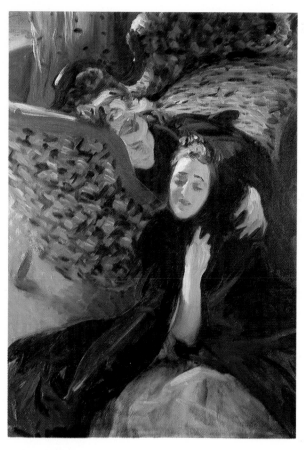

PLATE XLIII
Violet Sargent and Flora Priestly, 1889
Oil on canvas, 22″ × 16½″
Ormond Family

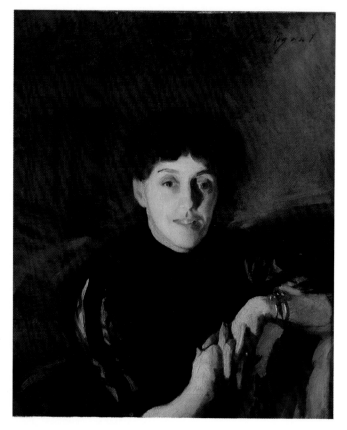

PLATE XLIV
Alma Strettel by Lamplight, 1889
Oil on canvas, 26″ × 21½″
Private collection

PLATE XLV
Landscape at Fladbury, 1889
Oil on canvas, 19½″ × 26¾″
Private collection

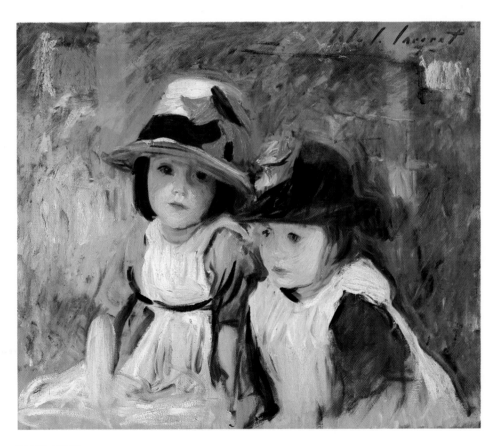

PLATE XLVI
Village Children, 1890
Oil on canvas, 25″ × 30″
Yale University Art Gallery, Edwin Austin Abbey
 Memorial Collection

PLATE XLVII
Still Life with Daffodils, 1890
Oil on canvas, 32″ × 18″
Yale University Art Gallery, Edwin Austin Abbey
 Memorial Collection

Photo credits:

Quesada/Burke: PLATES III, VI, XIV, XVI,
XVIII, XX, XXII, XXIII, XXVII, XXVIII,
XXX, XXXI, XXXVII, XXXVIII

John Lutsch: PLATE XLIV

Design: Marcus Ratliff Inc., New York
Typesetting: Trufont Typographers, New York